Photographs that make you think.

D1532426

ANIMALS

Henry Carroll

ABRAMS IMAGE, NEW YORK

CONTENTS

88
Symbolism

HEJI SHIN · ELENA HELFRECHT · DANIEL NAUDÉ
MASAHISA FUKASE · CHRISTIAN HOUGE
YORGOS YATROMANOLAKIS · GRACIELA ITURBIDE
MADHAVAN PALANISAMY

114
Interaction

ED PANAR · SAGE SOHIER · CLÉMENT LAMBELET
AMY STEIN · DANIEL RANALLI · MASUDA YOSHINORI
EMILIO VAVARELLA · BASTIAN THIERY

▬▬▬

Intro

I've never been to the Arctic. I have no memory of seeing a polar bear. But a polar bear is, and always will be, my favorite animal. I grew up with two dogs, three cats, a rabbit, a duck, a lamb, four birds, and an unknown number of goldfish, and, right now, there is a dachshund named Basil snoozing on my lap. How would all these animals feel if they knew that my favorite animal is one I have never encountered? I would, in my defense, try to explain to them that my fondness was not based on polar bears being living, breathing animals. I would say that it was like a celebrity crush, a superficial relationship based entirely on the idea, or image, of the animal, a somewhat delusional image—polar bears as lovers of ice cream and soft drinks, as friendly, cuddly giants with a lumbering gait and fur as pristinely white as the frozen world they inhabit. I would go on to reassure my council of pets that I can't say with certainty if it mattered to me as a boy that polar bears actually existed. That I can't say with certainty how I would feel, as an adult, if they became extinct. As an "animal lover," I would be sad, of course, but is it possible to grieve an animal that is, for me, imaginary? What will I have lost if the polar bear is lost? After all, the bears' image will live on, and it was their image that captivated me in the first place.

The state of mental and physical separation between humans and animals has largely been blamed on the Industrial Revolution and the growth of cities, but the all-consuming rise of image culture has also played its part. Animals both familiar and exotic exist to us now mainly as cartoons, brand figureheads, and wholesome illustrations on food packaging, and when many of us do encounter animals that were once part of daily life—cows, pigs, sheep, and goats—they are reduced to spectacles that require a ticket to touch. Though we remain close to our pets, they are often used as social media stooges, or dressed up and personified

through memes. We pamper pets like people—of course we do—and assume that what makes us happy (regular baths, clean sheets, and filtered water) makes them happy, too. And, to some extent, it obviously does. But I've met truffle dogs that live outside, in cages covered with their own piss and shit, that seem equally high on life—perhaps even more so, because maybe, just maybe, that standard of domestication remains respectful to what the dogs are. In short, they are animals— animals that derive a great deal of pleasure from sticking their noses in places that humans don't.

duction

And then there is wildlife photography. In this arena of still and moving images, animals have become a dazzling means to illustrate the marvels of the medium. The captions in wildlife photography exhibitions routinely feature more information about shutter speeds, f-stops, and focal lengths than information about animals, and nature programs come with behind-the-scenes bonus episodes where the people take center stage, as if that is where our fascination really lies. And though it is no mean feat to freeze the frenzied flaps of a hummingbird's wings or focus on the whites of a tiger's eyes at a thousand yards, wildlife photography only ever offers a very superficial view of animals. It does, in many ways, the opposite of what it intends. Rather than strengthen our bond, it aestheticizes animals, reduces them to decoration or entertainment, thereby emotionally distancing us from them—the real them.

Consider, for instance, David Attenborough. When Attenborough joined Instagram in 2020, he reached one million followers faster than anyone else ever had. After just four hours and forty-four minutes, he had smashed Jennifer Aniston's previous record of five hours and sixteen minutes. One can only assume that it wasn't the ninety-four-year-old's bonhomie that attracted so many followers, but rather their appetite for the images of exotic animals that Attenborough was sure to post. This is not to deny Attenborough's achievements: He has done more than any other living person to raise awareness of the natural world. It's just that he knows, as do his camera crews, that modern audiences will engage with the plight of the critically endangered *Isthmohyla rivularis* tree frog only if it is made hyperreal—if it's portrayed as a glossier, more saturated, and charismatic version of itself. Otherwise, it is just a frog. And you can't cuddle a frog.

We tend to view animals not as they are but as what we want them to be.

So where does this leave us? Given that our main source of information about the natural world also contributes to our separation from it, how can we rediscover a meaningful, authentic relationship with the animal kingdom at such a critical time, when it is not just the survival of other species at stake, but our own?

Here is a collection of photographers who dive into the depths of their own observations, experiences, and psychology to raise intriguing questions about how we relate to animals in the Anthropocene. Drawing on the nuances of visual language to provoke meaningful thought, they challenge preconceptions and call established conventions to account. Tim Hawkinson's

collage of an octopus, for example, offers a new and honest way of thinking about the physicality of animals and our resulting prejudices; Elena Helfrecht's surreal visualizations of childhood memories and Yorgos Yatromanolakis's nocturnes of a Greek island probe the significance of animals both personal and cosmic. Irene Fenara's algorithmically induced tapestries of image fragments offer an alternative view of consumption; Ed Panar's surveillance network of eyes draws out the profundity of our everyday interactions with animals; and Kiluanji Kia Henda exposes the absurdity of natural-history conventions to target colonial depictions of Africa.

Some of the photographers confront the difficult topics head on, others take a more oblique approach, using humor and eccentricity to engage us with important issues that have become all too easy to overlook. Rather than reinforce the divide between humans and animals, their work brings us closer; it allows us to reflect on a complicated relationship, a relationship in which we tend to view animals not as they are but as what we want them to be. Yet even though these photographers train their lenses on animals, their real subject is always humanity. After all, we are the one species that insists on renouncing its place within the animal kingdom. It may be inevitable, then, that the ways in which we imagine, categorize, consume, and interact with animals say more about us than about them. And when we see through the eyes of these photographers, when we become absorbed in their images and ideas, we find ourselves presented with what we now have no choice but to acknowledge: that the strangest, most inexplicable creatures on the planet are not animals, but us.

Physi

For those living off the land, which used to be all of us, the way an animal looked—its size, sturdiness, body shape, and resulting strength—gave it a function, whether to uproot trees or to pull a cart. Animals' physicality led us to value and respect the power and efficiency of some and to happily eat others. Since the Industrial Revolution, machines have replaced work animals and put an end to the close relationship we formed with them over thousands of years. Perhaps that is why we have a habit of talking affectionately to cars and kicking broken lawnmowers: Deep down, we still relate to these machines as if they were animals.

Sometimes physical familiarity, rather than function, is what determines our relationship to animals. It seems that the less we see of ourselves in an animal, the harder it becomes to feel affection and empathy, to form emotional bonds. I pity the animals with more than four limbs, or no limbs at all, the ones with no clearly identifiable head or eyes, the wrigglers and flappers, the floaters and crawlers—these poor creatures have become the focus of our phobias, repulsion, and prejudice, subjects onto which we project our own physical insecurities. It is, of course, entirely our problem, not theirs, because in almost all cases, their bodies are the result of a far longer and more honed evolutionary process.

cal

ity

The less we see of ourselves in an animal, the harder it becomes to feel affection and empathy.

The photographers represented in the following pages reflect how our relationship to animals is affected by the way they look, and the way we look. They show us how we interpret the physicality of animals through the lens of social and cultural conventions, a long history of representation, and our human biology. The photographers' gazes are direct and inquisitive, and in picturing the outward appearance of animals, they somehow manage to probe the inner workings of the human psyche. They show us that the way we look upon and judge animals is mixed up with all kinds of suppressed animal instincts that still reside within our minds; very primal instincts that go some way toward explaining how we look upon and judge ourselves and others.

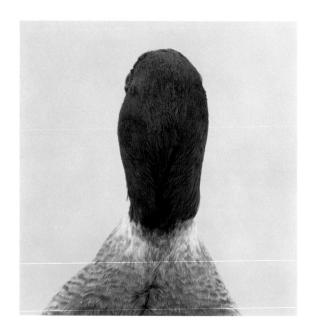

Are you physically attracted to some animals?

Seen from behind, these bulbous sculptural forms appear unfamiliar, strangely abstract, almost sensual. I can just imagine reaching out and placing my hand on one of those soft, downy necks. Bird is the name that Roni Horn has given to her collection of paired images of taxidermied Icelandic wildfowl. There is a respectful, human quality to the way these birds have been photographed, positioned against a white background under soft, uniform lighting. Though each pair of birds is superficially similar,

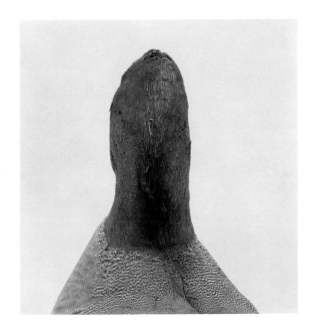

subtle differences in color, pattern, and texture become apparent when we view them side by side. I am, for what it's worth, drawn a little more to the bird on the right. That copper head and graceful drop of the left shoulder. Oh yes. Furthermore, Horn's use of the title Bird in singular form starts to take on an intentionally simplistic connotation. It illustrates our tendency to overlook the individuality of animals in order to avoid the "inconvenience" of empathy, which might lead to some kind of emotional connection. This is especially true with wild animals, in this case game birds, whose bodies and behaviors, infinitely various and elegant, are so often seen as nothing more than moving targets.

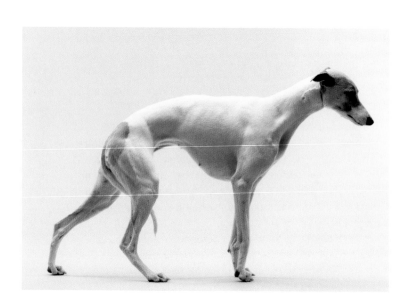

The Refusal (Part I), 2008

**Is it wrong
to judge
an animal
by its looks?**

I'm sure this dog would much rather its nose be aimed at a distant hare than be angled precisely at forty-five degrees. The dog is a whippet, bred to meet the stringent guidelines of perfection specified by the Kennel Club of Great Britain. The pose, however, is apparently far from perfect. According to the photographer, Jo Longhurst, the dog "very deliberately stepped out of line," which she went on to describe as "a defiant if futile move." Perhaps this sight hound had grown tired of being looked at. After all, it doesn't know it is the whippet equivalent of Kate Moss.

Much like the dog's breeder, photographers are also in a constant quest for visual perfection, which makes this display of canine resistance intriguing. What should have been an outtake instead marked the beginning of a body of work that saw Longhurst traveling the United Kingdom in order to photograph the country's most perfectly bred whippets. In Twelve Dogs, Twelve Bitches we see just that. Our gaze lands on each dog while it stands passively looking to the right. This consistent way of photographing the dogs allows us to study each animal as an object, assessing which lines, textures, and proportions we like best. The dogs, once bred for hunting and speed, are stripped of any function. They exist only to be looked at, but what exactly are we seeing?

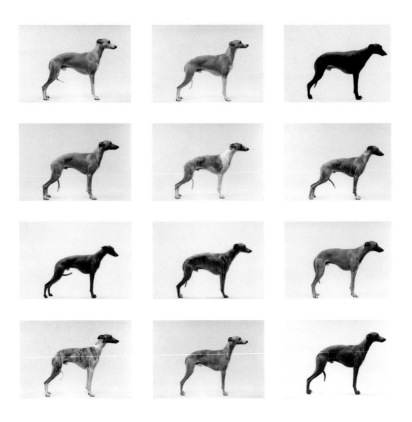

Longhurst's series offers us greater insights into ourselves—and our obsession with the way things look—than into dogs. Her images expose how loaded our gaze is, and how this specific way of seeing ends up changing the way animals look. Though some animals, particularly birds, are also influenced by physical beauty, the mechanics of Darwinian sexual selection seem highly practical, a means to find a healthy mate rather than something vulnerable to

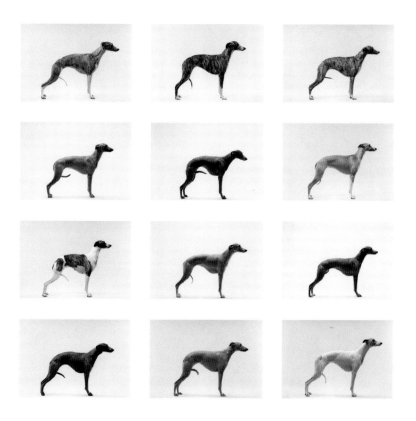

cultural whims. In many ways, our faddish appreciation of beauty is a privilege, a sign of our superiority over animals, but with that privilege also come extreme social and psychological burdens. We so want the dogs to be perfect, but none of them are, because perfection is unachievable. Perhaps we should, in fact, envy the eyes of animals.

Twelve Dogs, Twelve Bitches, 2003

Do insects know they are small?

The moth is, of course, oblivious to the fact that it has landed on a webcam and that its every move is being beamed around the world. It is, of course, equally oblivious to the significance of the view it has photobombed.

This chance encounter was screenshot by Kurt Caviezel, and is just one of many "creatures caught on web camera" moments from his series Insects. Caviezel regularly tuned in to existing webcams that have been installed all over the world to passively record anything and everything, from ancient wonders to bus shelters. In this screenshot, we see some of the pinnacles of human ingenuity, things that we consider to be world changing: the Egyptian pyramids, photography, digital communication, and global connectivity. Yet to this tiny creature, these wonders are meaningless; all it cares about is finding a flat surface on which to rest momentarily.

Although at first glance the most striking thing about this image may be the fact that the moth looks nearly as large as the Pyramids, the real wonder that Caviezel has immortalized here is the tension between humankind and nature. There is something about this compression of macro and micro, something wholly refreshing about seeing such a small, insignificant creature exercising a complete disregard for human civilization. In so doing, the moth inadvertently makes itself physically monumental and challenges the arrogance of human achievement, and our notion that we are somehow above all other living creatures. Like an alien being from an advanced world, this moth is reminding us that it is far more complex, far more significant, than a pile of old stones.

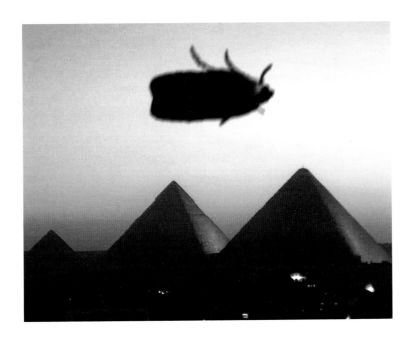

INSECT 26, 2011

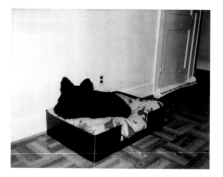

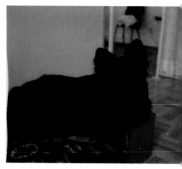

Photos from In Almost Every Picture #9 (Black Dog), 2010

Do cameras see all subjects as equal?

It appears in the photos as a black blob. It is only the two distinct triangles at the top that make the silhouette recognizable as a dog. This album of failed attempts was found by Erik Kessels in a flea market and forms the ninth chapter in his ongoing series of found images titled In Almost Every Picture. From one image to the next, the dog's dark fur defies a couple's attempts to record their beloved pooch successfully on film.

Today, it is all too easy to discard or delete our photographic mistakes, but perhaps the cost of a Polaroid prompted the couple to keep every picture, even though each represented a disappointment—an ungranted wish. The dog itself becomes a mysterious, almost sinister presence, as if intentionally withholding its image, resisting, for some reason, the imposition of being captured on camera. But, of course, the dog is entirely innocent, its willingness to pose repeatedly indicating its good nature. It is photography that's to blame.

The blackness of the dog means that it was always going to be overlooked by the camera's primitive exposure meter in favor of the brighter domestic surroundings, resulting in a collection of images immortalizing rooms, flower beds, and furniture of the era. The camera's inbuilt refusal to grant the dog its picture, while favoring such generic subjects, starts to feel like an act of bias against a subject that cannot help the way it looks. Photography's visual stubbornness is further exposed, or overexposed, in the final image of Kessels's collection. Intentionally or not, the couple did eventually succeed in capturing their dog's face on camera, but only as a result of a malfunction. Here, photography's limitations were overcome not by technical mastery but by determination and sheer love for a subject that deserved to be seen on film.

Do animals suffer from phobias?

Unlike the photographer, Juul Kraijer, the snake is not concerned with aesthetics. Under the beautiful chiaroscuro lighting, the animal has contorted its own path around the model's head, intuitively responding to the contours of the skull, chin, nose, and mouth. It has no idea that the line it has created with its body takes us on a melodic journey through the image. In these moments where snake and human forms become synergized, our initial shock, perhaps even repulsion, gives way to an appreciation of beauty, as reality ebbs into surreality. The model is careful not to dispel this state of in-betweenness. She is clearly posing, yet her comfort level is unclear. Her closed eyes and slightly tilted head could indicate a state of serenity, the result of a sensory encounter of scales on skin. But they could also betray tension, a holding of the breath while waiting for the creature to exercise its free will over her body.

In other images, the model's nude body becomes intertwined with the reptile. Rather than the snake appearing like an accessory, something that has been put on the model, both beings are naked and equal, photographed against blackness in a state of timeless alienation. There is a touch of mysticism in Kraijer's images, of mysterious matters that defy reason or explanation. Like so many others throughout history, we, too, find ourselves giving in to the snake's will. Yet here, the animal associated with a loss of innocence wishes only to reclaim its own. Its only means of temptation is its physicality.

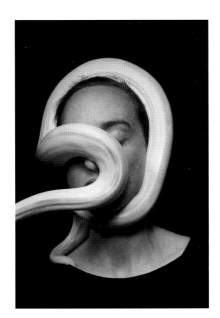

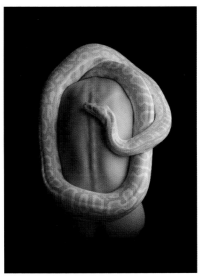

Top and bottom: Untitled, 2017–19

What's weirder— an octopus body or yours?

They each have nine brains, eight arms, and three hearts. Their blood runs blue, and with no bones, they can squeeze through the smallest of openings. Octopuses could not be further removed from the human body. Not only that, these strange creatures live in a mysterious, alien world, one we are no better suited to than we are to outer space. However, look closely at Tim Hawkinson's octopus and you will start to see that this creature from the deep is not so unfamiliar. It is, in fact, a collage made up of human body parts—Hawkinson's, to be exact.

The palm of his hand forms the bulk of the beast, his fingers its arms, and his puckered lips and folded tongue its suckers. Taking as his starting point a creature we perceive as otherworldly, unrelatable, and monstrous, Hawkinson has confronted us with a portrait of ourselves, a comical reminder that how we

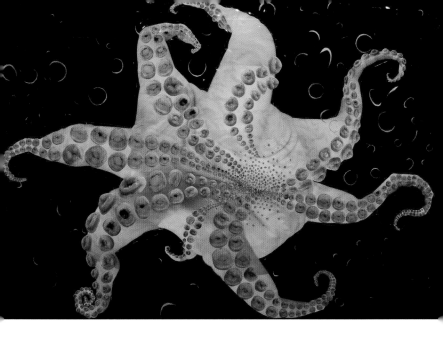

perceive some animals is as much about our own physicality as theirs. Is Hawkinson suggesting that our innate repulsion toward outlandish-looking creatures stems from a latent disgust with our own, human body? Could it be that it is not the octopus that is so strange, but us? After all, humans are the only animal that insists on torturing itself with images of "perfect" versions of its own body. Some of these aspirational images present bodies that lie beyond the possibilities of nature and practicality. That would seem to suggest we simply do not like what we see in the mirror. I doubt very much that an octopus looks at itself and feels any form of insecurity at all. How lovely it must be to be entirely contented with one's appearance.

Octopus, 2007

A disturbing transformation takes place in Ilona Szwarc's series Unsex Me Here. A woman, isolated and alone in a perfectly manicured Palm Springs mansion, sheds the confines of her femininity

What is your inner animal and why?

to become something wild and undefinable. The real and the imaginary are impossible to distinguish. In some images, the female protagonist appears normal, albeit a little passive, as she poses with a German shepherd. In others, she sits at her makeup table, besnouted, with long hair growing from her hands, and the dog has become a ceramic figurine.

Adopting a glossy style and bubblegum pinks often associated with high-end photo shoots, Szwarc uses the motif of a woman transforming into a werewolf-like creature to explore notions of conformity and female identity. In particular, this series depicts a narrative rooted in her own struggles as an Eastern European woman living in the United States. As an immigrant, Szwarc has remarked that she easily adapted to the social and physical expectations of being an American woman, but her childhood memories, one of which includes being violently bitten by her own dog, are attached to a very different time and place. In this transformation from human to animal, Szwarc unveils the hidden traumas that lie under the skin when one is forced to adapt oneself to the demands of a new culture.

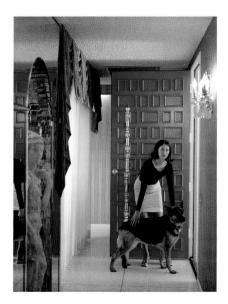

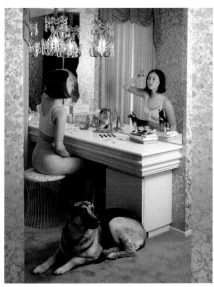

Top: *Speaking with Low Voice to the Animals*, 2019 | Bottom: *Grinning and Crying*, 2019

Top: *Her Hands Seemed to Take the Place of the Eye*, 2019
Bottom: *This Girl Were the Converging Halves of a Broken Fate*, 2019
Opposite: *Sometimes One Meets a Woman Who Is Beast Turning Human*, 2019

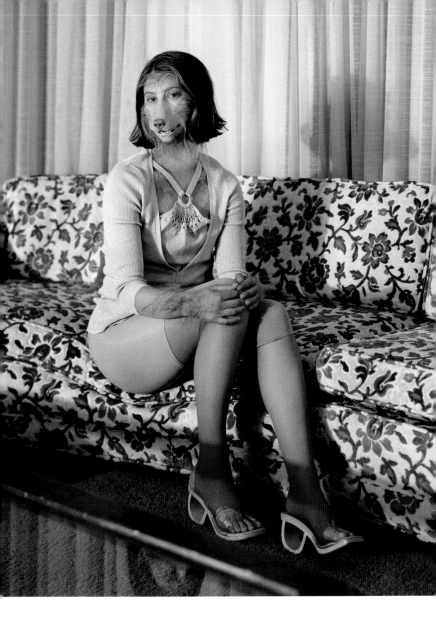

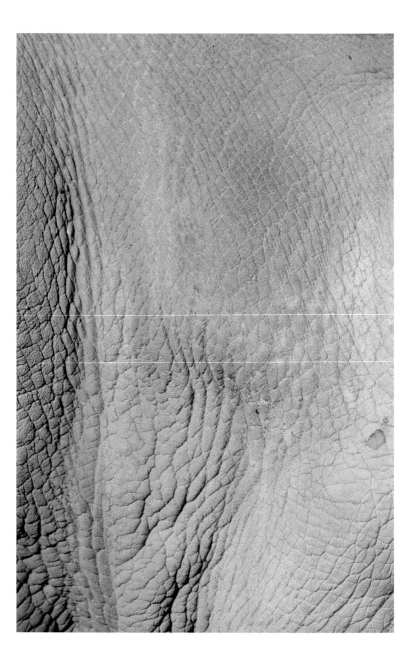

Have you ever really seen an animal?

A dried mound of clay? An aerial photograph of a parched riverbed? Perhaps even the lunar surface? Many things can be seen in Giovanna Silva's photographs of Sudan, the last surviving male northern white rhinoceros. One thing that cannot be seen, however, is Sudan himself—at least, not a complete picture of him. Silva spent ten days photographing Sudan in Kenya, where he lived in a breeding facility under armed guard. The result is a series of intimate close-ups of his aging skin, titled Good Boy 0372—"good boy" being the affectionate phrase used by those who cared for Sudan, and "0372" being his somewhat less intimate "breeding number."

Silva printed each image of this series successively lighter, until, in the final one, Sudan's body is barely a trace. Some images are abstract. Others show more identifying features, such as an eye or a horn. By denying us a complete picture of this precious animal, Silva leaves us to piece together his majesty in our minds, a process that allows him to slip into our imagination. This vanishing is reminiscent of the Indian parable "The Blind Men and the Elephant," in which blind men who have no concept of an elephant are unable to understand what it is through touch. They think its leg is a tree, its trunk a snake, and its ear a fan. In a sense, we are at risk of becoming those blind men; Sudan died not long after Silva completed her series. Now only two northern white rhinoceros remain, both of which are female.

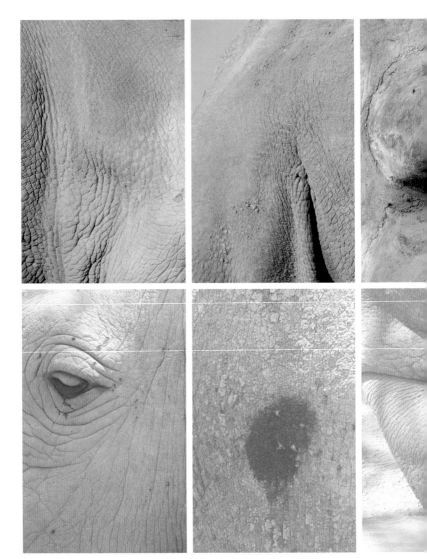

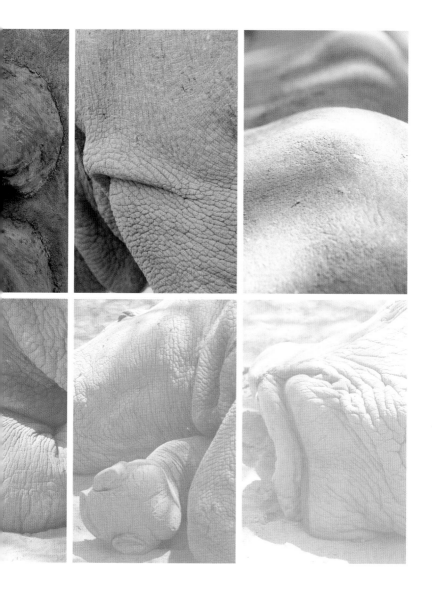

Photos from the series Good Boy 0372, 2016

My birthday falls on an awkward date in September that made it hard for the United Kingdom school system to classify me, being either too young or too old for a year group. The upshot of my hybridity was that at age seven I was made to repeat a year at school, the year that our class visited London's Natural History Museum, meaning I had to endure the same outing, with the same worksheets, twice.

"Facts" require context, and our interest in specific animals is fickle at best.

All of the taxidermy in natural-history museums fills me with a deep unease, but there was one exhibit that I loved: a life-size replica of a blue whale. The first year I saw it, I was totally awestruck. The way this humongous animal was suspended turned the air into ocean and it was easy for my young mind to imagine swimming along beside it. The second year I saw the whale, my reaction was different. When I hurried into the great hall, the animal seemed a little smaller and its painted surface more muted. I suppose my imagination must have given life to the whale; I must have expected it to have changed, to have grown, to have moved, yet clearly it had spent the last year just hanging there, doing nothing whatsoever. The only thing that fascinated me was the thin and even layer of dust that had accumulated along the length of the whale's body.

The permanence of some natural-history exhibits implies that our understanding of animals is somehow set in stone. That everything is simply the way it is and that's that. However, our constant accumulation of knowledge means familiar theories evolve, "facts" require context, and our interest in specific animals is fickle at best. New studies about animal behavior are constantly surprising us. Often these studies throw up intriguing explanations as to how animals communicate and perceive the world—witness the theory that dogs "smell time." Scientific research and natural history are also vulnerable to fads. A blockbuster movie about penguins, for example, might prompt museums around the world to reorder their Antarctica displays, which, in turn, shifts around the natural order of things in the minds of visitors. Money gets plowed into penguins, when it should perhaps go to plankton, the creator of half the world's oxygen supply.

The photographers in this section are not scientists, they are artists, which makes them perfectly placed to unpack, or play with, the conventions of natural history that continue to shape our understanding of animals. They turn their attention to the customs of museum displays, the language of research, concerns about colonialism, and our obsession with size. With humor and an open mind, they explore the borderlines between art and knowledge to show us that natural history and our understanding of animals is the product of politics as well as science.

History

Is photography
a kind of
taxidermy?

"I would never understand photography, the sneaky, murderous taxidermy of it," wrote Lorrie Moore in her novel *Anagrams*. This contemplation on the nature of photography is brought to life, so to speak, in Klaus Pichler's behind-the-scenes photographs of Vienna's Natural History Museum. Sharks swim around stairwell corners, grizzly bears occupy elevators, and elk line corridors. This surplus of taxidermied creatures, freed from the formality of display cases, appears to run amok in the bowels of the museum. The uncanny nature of taxidermy makes it fascinating subject matter for photographers; a once living, breathing, roaring being has been killed, stuffed, and preserved, often in a movement pose, like a ready-made photograph. The photographer then freezes what is already frozen.

In the case of Pichler's photographs, this "double death" opens up a peculiar imaginary space in which supposed new life has been breathed back into these creatures. In other words, we expect photography to be still, and therefore it's easier to bypass the static state in which these animals exist in reality and see them as living subjects. Like hallucinations, these animals are entirely out of context—apart not only from their natural habitats in the wild but also from the wholly unnatural habitats of the pristinely presented displays that the museum has created for them. The taxidermizing effects of photography imposed on taxidermy unlock our imaginations. Wild animals that would never normally come into contact with one other are thrown together to create a new ecosystem of impossibility.

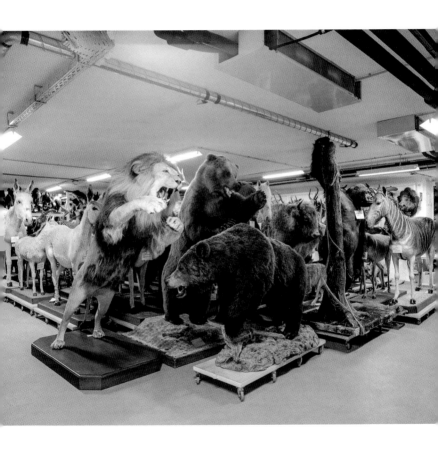

Mammal Collection, 2012

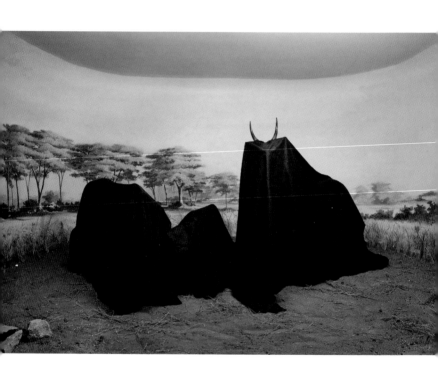

In the Days of a Dark Safari #1, 2017

Museum dioramas depicting African wildlife and landscapes become a stage for Kiluanji Kia Henda to dramatize his colonial concerns. His series In the Days of a Dark Safari presents taxidermied animals shrouded in black cloth. There is something menacing or funereal about the animals and their lifeless surroundings, yet humor and absurdity abound as protruding horns give us a clue as to what might be underneath the cloth. For Henda, the conventions of natural history, especially in museums, see foreigners pick and choose animals and artifacts in order to represent an entire continent in the eyes of visitors. Henda considers these now very established modes of representation as "hostile narratives," a process of exotification designed to make his homeland appear as "other" in the eyes of the world.

What does "Africa" look like?

The act of placing a shroud over these animals does two things. Firstly, it is an acknowledgment of lives lost (in this case, the lives of wild animals who wandered into the crosshairs of those hunting in the name of science). Secondly, it is an attempt to disrupt two polarizing images of Africa: one being a mysterious land of strange rituals and darkness often depicted in literature, and the other being the place of perfection, harmony, and natural equilibrium as seen in museums.

**EIRIK
JOHNSON**

Does knowledge limit
your imagination?

Anyone even vaguely familiar with Freudian psychoanalysis knows how preoccupied humans are with holes; we enter the world through a hole, we feed ourselves and others through a hole; children, especially little boys, like to stick things in holes; perverts peer through them and bodies are buried in them. My apologies—it's easy to disappear down a mental rabbit hole when looking at Eirik Johnson's extensive and ongoing photographic study titled Animal Holes. Unlike the displays of a natural historian, Johnson's holes are not captioned or classified; our understanding of them is not skewed by or limited to the animals that live inside them. Instead, we are asked to consider these voids in the ground simply as "holes."

What might live down there, and the scale and complexity of the unseen worlds beneath our feet, are for us to conceive. We enter into a form of scopophilia (pleasure derived from looking) fueled by a fascination with what we cannot see, rather than what we can. This unlocks a complex, unexpected psychological space that is often closed off by science's insistence on knowledge and understanding. No wonder a hole in the ground served as the gateway to one of the most fantastical literary journeys of all, Alice's Adventures in Wonderland.

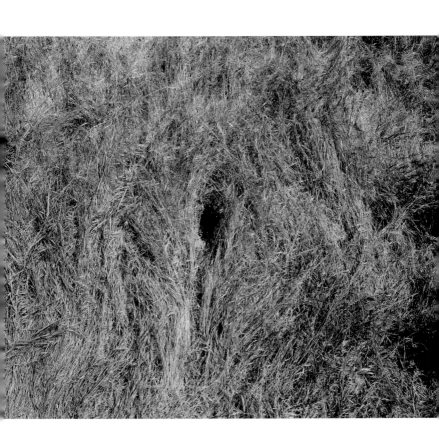

Photo from the series Animal Holes, 2006

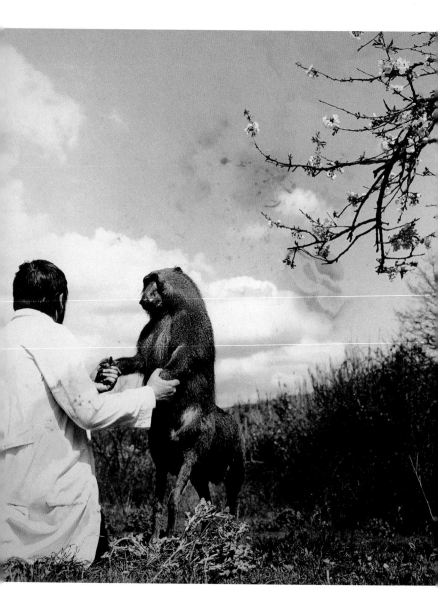

Centaurus Neandertalensis: *In Full Communication with Aaru-1*

JOAN
FONTCUBERTA

PERE
FORMIGUERA

Would you bet your life that dinosaurs really did exist?

Here, the German naturalist Professor Peter Ameisenhaufen communicates with a Centaurus, a highly evolved, semi-humanoid species that even Ameisenhaufen, with all his knowledge and experience, was unable to classify with total confidence. This old, stained photograph is just one article of evidence from the professor's extensive research archive, which includes field sketches, sound recordings, photographs, notes, and preserved specimens of strange creatures from around the world. It is, however, an archive entirely invented by the artists Joan Fontcuberta and Pere Formiguera, for whom the animal kingdom is the ideal arena in which to test the limits of our belief. After all, the sheer diversity of species and environments means it is just not possible for us to fully grasp what is and isn't beyond the realm of possibility.

By exploiting the formal conventions of museum displays, zoological documents, and archival imagery—systems we are programmed to trust from a very early age—Fontcuberta and Formiguera demonstrate how our willingness to believe, far from depending entirely on the content of what we perceive, is instead profoundly informed by context. In other words, nothing in nature is beyond belief if presented with enough authority.

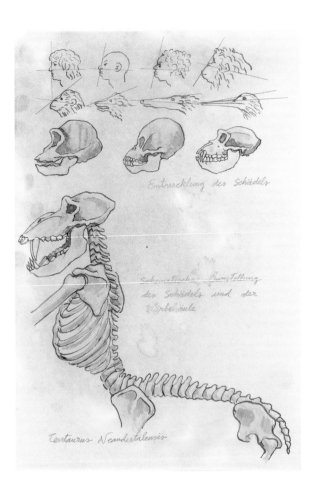

Entwicklung des Schädels

Schematische Darstellung des Schädels und der Wirbelsäule

Centaurus Neandertalensis

Above: Centaurus Neandertalensis: *Field Sketch of Cranium and Vertebrae*
Opposite: Alopex Stultus: *Position for Cautious Approach*

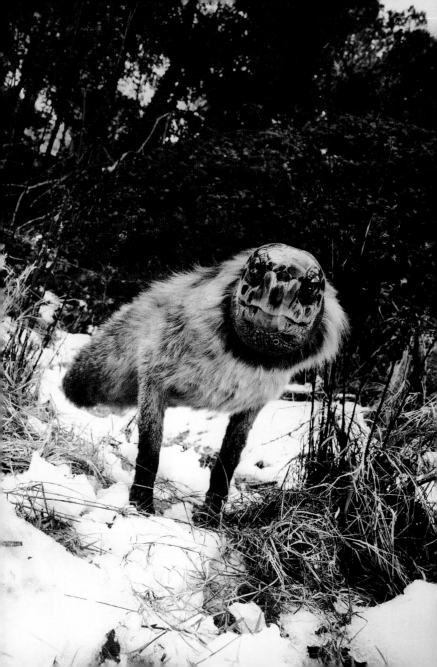

ANNE GEENE

ARJAN DE NOOY

Can science have a sense of humor?

Few animals have more deeply fascinated scientists and artists alike than birds. For the scientifically minded, the sheer variety of shapes, sizes, and songs begs to be classified, and for those concerned with beauty, birds' plumage and graceful movements make for irresistible subject matter. With their book *Ornithology*, Anne Geene and Arjan de Nooy occupy the gray zone between artistic and scientific representation. The table of contents, which includes sections on "Behavior and Migration" and "Reproduction and Oology," makes their book appear to be a dry scientific study. But as one begins thumbing through their observations, things become a little more tongue-in-beak.

In a section called "Velocity," we are invited to compare and contrast the various splatter patterns of bird poop. Some appear to have fallen vertically, forming neat, dense circles of white. Others look as if they have hit the ground with speed and from more acute angles. What, exactly, if anything, are we learning here? In the section on "Bird Geometrics," floating ducks form triangles or diagonal lines, and in "Camouflage," birds blend into their backgrounds. But these observations are as much the product of photographic timing as they are of bird behavior: Photographed a second or two later, the birds might no longer be in a line; captured from another angle, a bird will no longer blend into its background. In the end, this comprehensive catalog tells us much more about the conventions of representation than it does about birds. An alternative system of understanding animals emerges that is, itself, impossible to classify. Here, art pokes fun at science and science enjoys a little foray into art.

Above and following spread: *Velocity*, from *Ornithology*, 2016

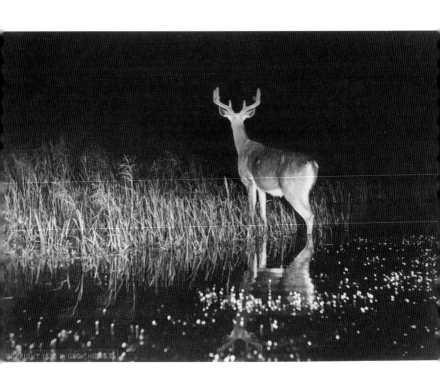

Hark!, 1898

A hunter who swapped his gun for a camera, George Shiras is often regarded as the first wildlife photographer. His lighting technique was inspired by the Ojibwe tribe, who would hunt at night by setting a small fire in a pan mounted on the bow of a canoe. When the invisible animals looked up at the light, all the Ojibwe had to do was aim their spears between two glowing dots in the darkness. Shiras's photographs often show animals staring quizzically into the lens, but they are clearly unaware of any human presence. Other images, made with "camera traps" triggered by trip wires, offer completely candid glimpses of undisturbed animals in the wild.

Looking at Shiras's photographs today, it's hard to imagine that they were taken more than one hundred years ago. There is no evidence of human presence, and nothing in the landscape speaks to

Do animals exist outside of time?

a specific time. Even the image quality holds up relatively well against modern standards of night photography. Most importantly, however, it is the animals themselves that refuse to be tied to an era. Unlike almost any other subject matter, the animals provide no clues as to when these photographs might have been taken. By existing outside of culture, they exist outside of time. It is only if and when a species in Shiras's photographs become extinct that his work will begin to slip into history. Let us hope his work lives on forever.

As someone at
the top of the food chain, are
you responsible for
the well-being of those
at the bottom?

What strange
creature are we
seeing here? Are
those wings or
fragile bones? How
large or small?

Is this a living being at all? Mandy Barker's image is mysterious
and beautiful—clearly a significant specimen, but of what?
With Beyond Drifting: Imperfectly Known Animals, Barker takes
her starting point in the research memoirs of military man-
turned-marine biologist John Vaughan Thompson, who, in 1830,
conducted a groundbreaking study of plankton in the seas around
Cork in southern Ireland. However, Barker's images do not depict
these tiny life-forms on which all life on Earth depends. They
depict the food of the creatures that exist at the bottom of the
food chain: plastic.

Barker collected these "specimens" from the same waters
in which Thompson conducted his studies, waters that would
have been clean of plastic two hundred years ago. Photographed
with a slow shutter speed and moved slightly during exposure,
the plastic pieces, which range from baby-stroller wheels to coat
hangers to plastic bags and action figures, appear to be floating in
fluid. The plastic takes on the appearance of plankton, but unlike
plankton, which is essential food for marine animals and creates
half the world's oxygen, ocean plastics have no benefit. In fact,
they cause irreversible harm, starting with the smallest life-forms
and working their way up the food chain. Barker's images draw us
in by treading the line between beauty and ugliness. Staring into
this round, crystal-like ball, we see an ominous fortune that is the
product of our own making. What appears microscopic is, in fact,
an unimaginable enormity affecting all life on Earth.

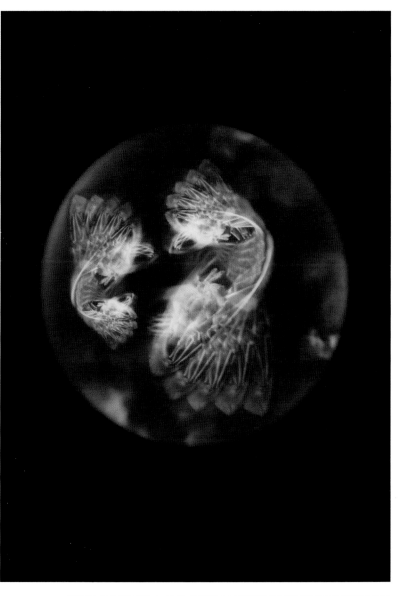

Ophelia medustica (Pram wheel), from Beyond Drifting: Imperfectly Known Animals, 2016.
Specimen collected from Glounthaune shoreline, Cove of Cork, Ireland.

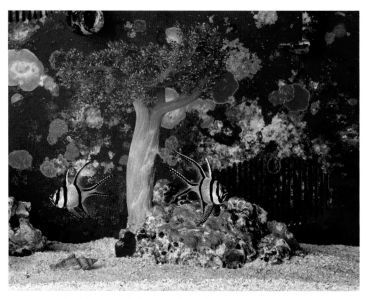

Top, bottom, and following spread: Photos from the series Appetite for the Magnificent, 2017

TANIA
WILLEN

DAVID
WILLEN

We find ourselves fully immersed in a highly aestheticized underwater world in Tania Willen and David Willen's photographs of aquariums, which present an all-too-perfect, almost psychedelic picture of marine life. It is the vivid colors and lighting that hit you first, then the clarity of it all. It is as if the fish are floating in air rather than water. The fish don't even feel like fish, more like actors, perhaps. Seeing them removed from the vast expanse of the ocean and placed in a glass box, one wonders what they must actually know about being a fish.

What happens outside a photograph?

This sense of theater, of construction, is heightened by the Willens' process. Rather than simply photograph the aquariums as they found them and light them, as would be usual, from above, they used lighting from the side, in order to enhance the presence and details of the scenery. Then, it was a case of calculating exposure times and waiting for the fish to float into position. They were, in a way, making images of images. But something a little unexpected happens when the world of the aquarium is contained within the world of the photograph. The glass walls of an aquarium mark the limits of imagination. There is no continuation of the constructed world, and we find ourselves standing in our own bone-dry reality. With a photograph, however, the edge of the frame does not mark the end of that world, only its slippage into what might exist off-frame, a world pregnant with limitless possibility. By denying us the boundaries of the world inside the tank, the Willens demolish its glass walls and allow us to imagine that these highly constructed stages could, in fact, extend forever. The act of photography releases the fish into the wild—albeit a pristine version of the wild that exists only in our imaginations.

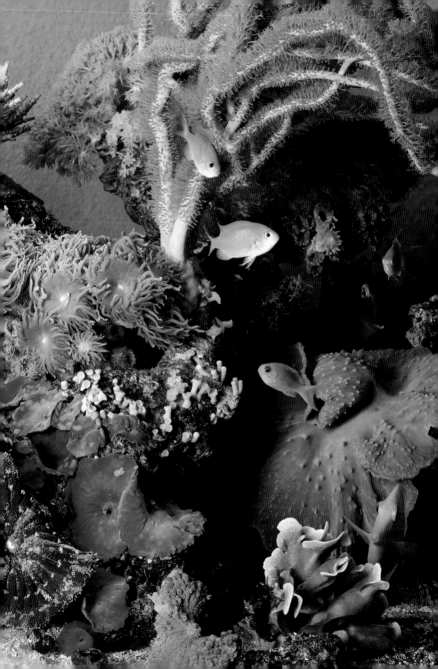

Is it
sometimes
OK
to be cruel
to animals?

Let's indulge in a little personification. What "expression" is on the face of this rufous-tailed hummingbird? Shock, resignation, panic, indifference, pleasure, confusion? While it's hard to tell, one thing is certain: The small bird would rather not be entangled in such a helpless predicament. The net was placed by ornithologists conducting research; the photograph was taken by Todd Forsgren. The bird was eventually released unharmed after being documented and tagged, yet Forsgren, a keen bird-watcher himself, draws our attention to the messy moment of capture. Adopting a clean studio aesthetic, as if the bird were an object of study, Forsgren hung a plain backdrop on the other side of the net and used a soft flash to illuminate the plumage. Yet the element of control ends with the bird itself.

Conventional depictions of birds by the likes of Roger Tory Peterson tend to display them in natural poses, to offer us insight into how they should look in the wild. The act of capture or kill for the purpose of study is hidden. Here, no such attempt has been made. As such, Forsgren confronts us with a fundamental contradiction: In order to protect animals, it seems we must abandon our empathy for them. We know that the bird is safe, and because of that, there is pleasure and fascination, even a touch of humor, when viewing Forsgren's portrait. But the bird does not know it is safe. Its freedom has been denied, and it finds itself in a position of complete powerlessness. Like a fly caught in a spider's web, the bird is staring death in the face. With his images, Forsgren ensnares us in a moral quandary. Whether or not it's for their own good, what right do we have to study animals if it means engaging in necessary acts of cruelty?

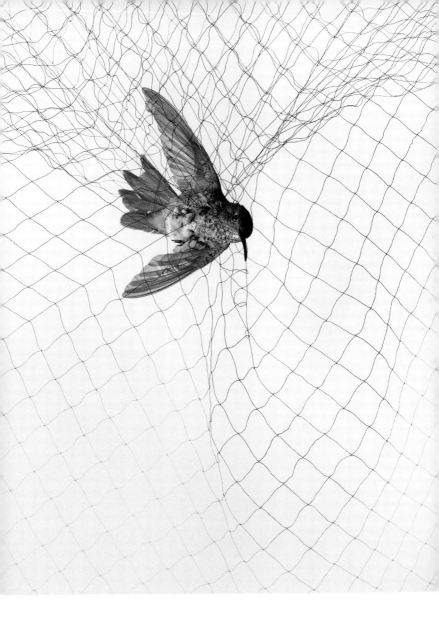

Rufous-tailed Hummingbird (Amazilia tzacatl), 2012

I was twelve when my mother came home with a lamb. Not a delicious cutlet or chop—a living, breathing animal. The lamb had been orphaned, and a local farmer asked if she might want it, otherwise it would have been slaughtered. In hindsight, I think his offering of a lamb was motivated more by his fancy for my mother than by his concern for the animal. I called the lamb Mimi, fed her milk from the bottle, and took her on walks with the dogs. I think Mimi thought she was a dog. It was easier for us to think of her that way, too, because on most Sundays our family would sit down to eat a roast dinner, and very often the main attraction would be lamb.

Consump

I'm sure, on occasion, Mimi was in the room, looking up at us as we feasted on the bloodied flesh of her distant relatives visiting from New Zealand. This, I know, is all quite macabre, but we never really stopped to think about it. Mimi was an individual animal with a name and distinctive personality. This, in our eyes, distinguished her fundamentally from the lamb on the table, which was nothing more than a "product" from a seemingly unlimited reserve of animals, one denied individuality and affection, and with only one purpose in life—to be consumed by humans.

This mental separation between animals as individuals and animals as an anonymous collective underscores much of the work in this section. Here, the photographers delve into the complicated psychology that has led us to make animals the primary victims of our culture

Our treatment of animals is rooted in a very human need for control and perfection.

of excess, a culture that results in the needless waste and inhumane treatment of living, feeling beings. Their work manages to find beauty in the act of slaughter, as well as drawing intriguing comparisons between the way we treat animals and the way we treat people. There is a suggestion that our treatment of animals is rooted in a very human need for control and in a quest for perfection: Even the definition of existence and extinction is called into question.

As for poor Mimi, it turns out that lambs, given the opportunity, grow into sheep, and sheep, being bulky and belligerent, do not make good pets. And so, it was decided that Mimi would be better off with a local farmer. We would visit her on weekends, but after a while her gaze became vacant as we slipped from her memory; stripped of her individual status and unable to integrate with the sheep collective, she became isolated and confused about what she was. I can't help wondering if our love for an animal that was not bred to be loved turned out to be, in its own way, an act of cruelty.

What will make us stop?

The artist Meryl McMaster is standing on top of Head-Smashed-In Buffalo Jump, a historical hunting ground used by her First Nations ancestors, the Nêhiyaw nation. Here, tribal hunters would drive bison off the ridge where they would tumble to their death and be used for food, clothes, and tools throughout the year. This seasonal ritual lasted more than six thousand years, until European settlers in the nineteenth century hunted the bison to near extinction over a few decades.

McMaster has a haunting presence in these images, confronting us with a hybrid form and a direct gaze. Her garments are a patchwork of symbols that speak to the opposing elements of her First Nations and European identities. The feathers are from the Canadian prairie chicken, a once abundant but now rare bird, the feathers of which were used in Nêhiyaw dance. Its distinctive tracks also form an abstract pattern on McMaster's coat. As for the top hat, this represents the demise of another animal, the beaver, which enticed colonizers ever westward in search of its luxurious fur, which was used for such fashion accessories.

In returning to the site and creating almost ritualistic self-portraits, McMaster reflects on her heritage, that of the Nêhiyaw, British, and Dutch, and the consequences of two distinctly opposing relationships to land and animals: one of long-term sustainability, the other of short-term exploitation. McMaster positions us at the edge of a real and metaphorical precipice. The sky is clear, and we can see for miles, but we are at risk of sharing the same fate as the charging bison—doomed juggernauts, animals so powerful that they could not reverse course even though they could see the cliff's edge approaching.

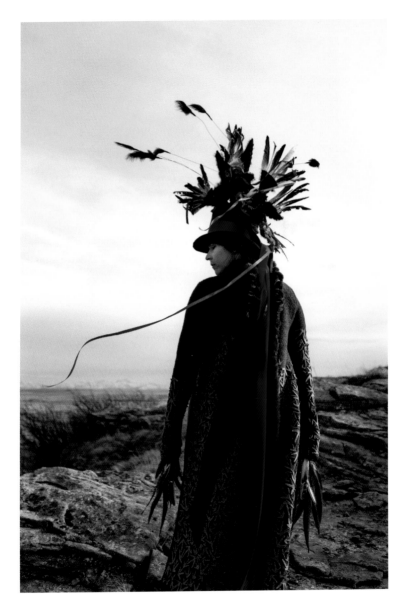

Edge of a Moment, 2017

Bring Me to This Place, 2017

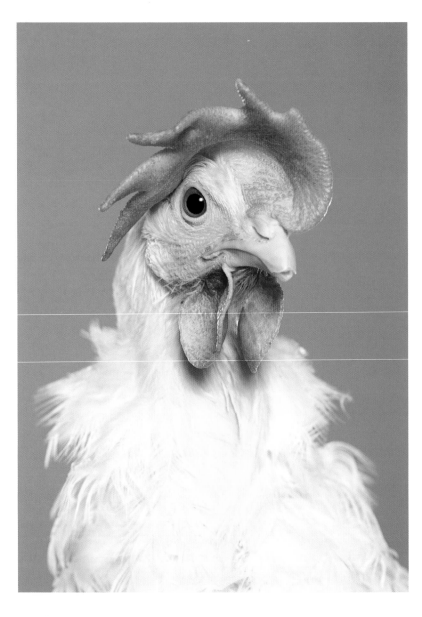

Hen 4304, from the series Novogen, 2017–18

Do you see yourself in this chicken?

Photographed against blue, with its pink comb swept back like a quiff and its feathers pristine white under the studio lights, this hen has a somewhat heroic demeanor. The clarity of Daniel Szalai's portrait, its color palette and composition, feels corporate, like this isn't any old chicken but one with a specific purpose. She is one of many hundreds of Novogen Whites, genetically engineered birds tasked with laying eggs of the highest quality that are used in the production of vaccines. With their various postures and body shapes, one can easily project human qualities onto the chickens in Szalai's grid of headshots. Each one is the same but different, individual but homogenous, like valued employees, hardworking members of a team.

There is something disturbingly relatable about these hens. Their repetitive existence, their specific job, their lifespans of exactly ninety weeks (after which the birds become inefficient and are incinerated) add up to an extreme version of our own capitalist life cycle. Like these chickens, when the majority of humans reach maturity, we, too, become assimilated into jobs that require us to be efficient, repetitive, and hardworking. And when we no longer perform due to age or premature burnout, we become worthless, a burden to a machine designed to be ever more efficient. Perhaps the only difference is that we, unlike these chickens, believe we have a choice. But do we really? By photographing these birds as if they were people, by exposing the human and inhumane dualities of their existence, Szalai shows us that our exploitation of animals is merely an extension of how we treat ourselves.

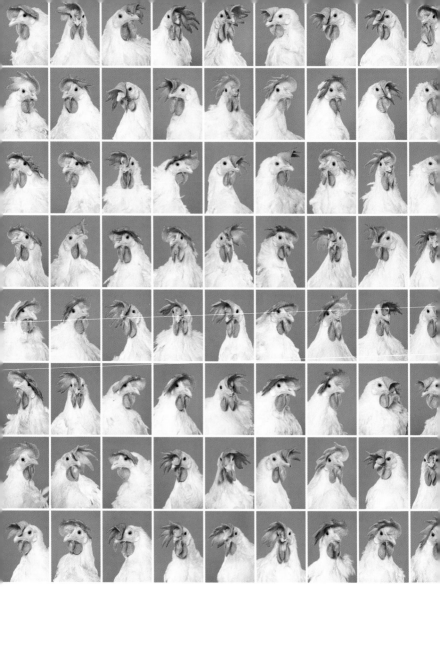

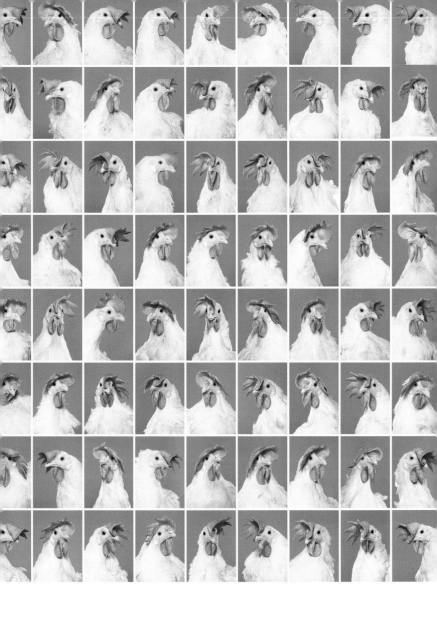

Workers' Tableau, from the series Novogen, 2017–18

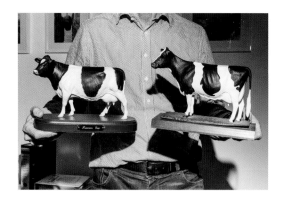

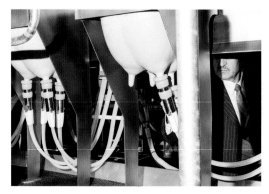

Above and following spread: Photos from the series Hornless Heritage, 2014–17

What, exactly,
fuels our
appetite for
animals?

Nikita Teryoshin takes us inside the world of German cattle
auctions and agricultural fairs to offer a behind-the-scenes
glimpse of the modern-day dairy cow. Known as turbo cows,
these animals are the product of ever-advancing technology,
having been bred over decades to satisfy the thirst of milk
lovers. Teryoshin's use of direct flash adds visual razzle-dazzle
to the proceedings, as we see ominous-looking men in black
suits pursuing the latest milking machines and ogling prizewin-
ning cows. In many of his images, the cow is represented as a
piece of technology, rather than as a warm-blooded animal.
A computer screen fills one composition, the numbers on
displays representing the genome sequence of a specific breed
of cow; a man resembling Inspector Clouseau eyes up a set of
artificial udders that form part of a milking machine demon-
stration. The president of a breeders association holds up two
models showing what a difference forty years of breeding has
made to a Holstein cow.

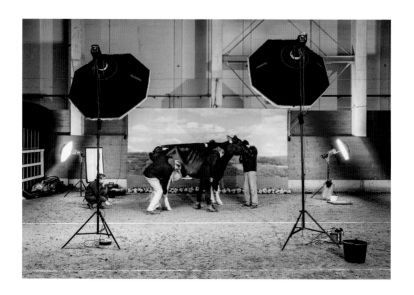

There's something comical, but also a little clandestine, about the way the men seem to observe and interact with the cows. No doubt, conversations about performance and design are taking place here not unlike those you might overhear at a car show. In the eyes of these men, the cow, which is, of course, female, becomes an object of control, a subject to tinker with, to meet the highest possible standards of form and function in order to surpass the competition. With his visually arresting photographs,

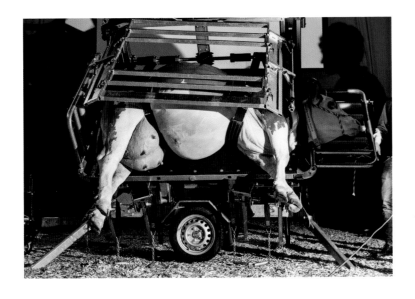

Teryoshin brings to the surface a fascinating point of view on the role of animals in consumer culture. He is suggesting that our obsessive desire to alter and enhance animals is motivated by something a little more complicated than a need to produce more food. Through his lens, these agricultural gatherings seem less about milk and more an opportunity to indulge certain distinctly masculine desires relating to the female body.

How might an animal view technology?

Alfio Tommasini takes us back to the place where it all began. That is, the place in the Swiss Alps where, around seven thousand years ago, humans first evolved the ability to digest the lactose in cow's milk—a little freak of nature that gave birth to the modern dairy industry. Tommasini presents a picture of dairy farming that is both ancient and modern, a process dependent on a close connection between humans, animals, and land, as well as technology.

His photographs of smallholder farmers are earthy and intimate. Though most of the photographs were made during the harsh winter months, a tactile warmth permeates the images. The weathered hands of farm workers on their animals is a recurring motif in Tommasini's images, and his diptychs imply an almost spiritual

symbiosis between animals and landscape; the lines of topographic features are echoed in the markings on animals; warm milk resembles cold snow; exposed earth could be mistaken for cow hides.

Occasionally we see inside high-tech laboratories. In opposition to the cowsheds and mountain tracks, these spaces are climate controlled and cleaner than clean. Caged in by technology and touched by human hands gloved in latex, the cows make a sudden shift from animal to product. They appear out of place, and the primordial connection with humans—the state of respectful codependence that has been in place for thousands of years—is broken. In Tommasini's images we see another evolution taking place, this time technological rather than biological. And with our relatively newfound taste for technology, it is easy to see what we are giving up. Harder to see is what there is to gain.

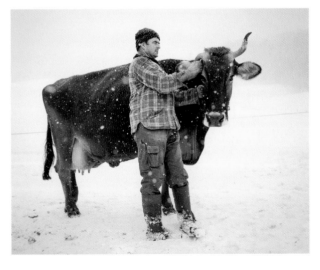

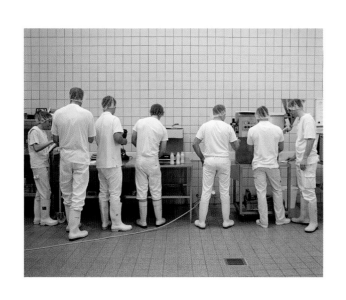

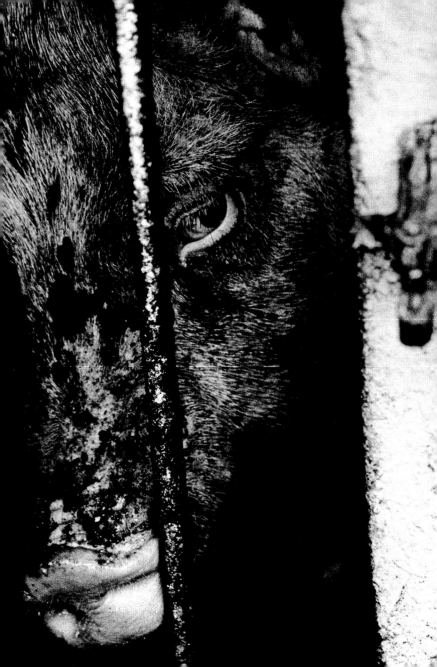

Nozomi Iijima grew up on a farm. She lived in a house nestled between the pigpen and the cowshed. Unlike other children, her relationship to animals was not formed by picture books. She was surrounded by the sound of mooing, grunting, and squealing and the smells of livestock, grain, and manure. The seasons cycled, Iijima grew older, but the animals never did—most were born and slaughtered within six months.

Who are you to judge how animals are treated?

In Scoffing Pig, Iijima's visual language continues in the traditions of Japanese photographers such as Daidō Moriyama and Masahisa Fukase, whose visceral use of grainy, dense, and blurred black and white seems to feed off its subject rather than document it. You can almost feel the damp breath of the animals as they press their snouts through the bars of their cages, hear their muffled grunting as they nuzzle the mud. Photographs of pigs, vegetable scraps, desolate farm buildings, winter fields, and animals in transit present a picture of livestock that spend their lives consuming in order to be consumed. But Iijima is not just photographing a farm. She is photographing her home. The place where she, too, was born and raised by the same people who tend to the animals. Her photographs betray the complex psychological turmoil that arises from growing up around farm animals destined to be slaughtered. Though the animals are confined and denied freedom or a life, they are also the family's livelihood; their condition, in many ways, provided security for Iijima as a child, and for a future in itself.

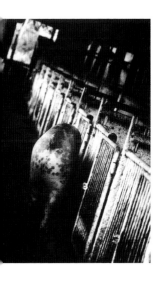

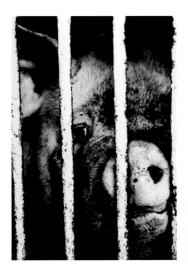

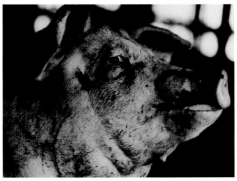

Above and page 76: Photos from the series Scoffing Pig, 2004-9

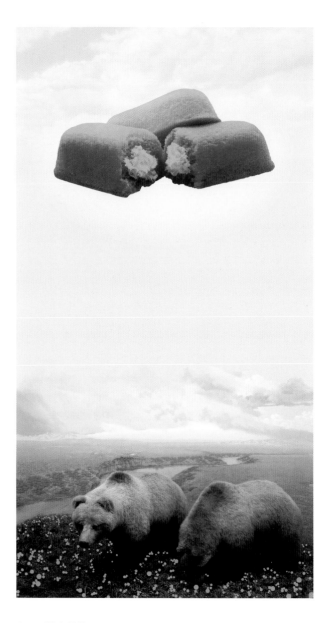

Cream Filled, 2007

Why is artifice so enticing?

Two grizzly bears wander through a beautiful meadow of orange dots that resemble wildflowers. Above them, three Twinkies hover in the sky like edible angels, their forms strangely similar to those of the bears beneath. The bears are, of course, part of a natural-history display, stuffed like the cream-filled puffs above them. And if one were to study the list of ingredients of these spongy entities, one would no doubt discover that some unexpected animal extracts had found their way into the food. There is authenticity here, albeit in trace amounts. The bears are, in a sense, real; they were living, breathing animals before becoming part of the museum display. And while the food above them is edible, it is a very modern interpretation of food that contains almost no nutritional value.

Creating digitally collaged compositions of taxidermied animals, food products, and sticker-like motifs from advertising, Jason DeMarte fashions a seemingly absurd visual language that highlights the superficiality of consumer culture, a culture that depicts animals, nature, and food as idealized, ordered, and guilt-free. Experiencing his works is a little like having a carrot dangled in front of our faces, only when we reach out to grab it, we discover it's made of plastic. This yearning for "the real thing" exposes the gaping divide between reality and representation, between the natural world and our experience of it (or lack thereof). For the vast majority of us, our daily encounters with animals have been reduced to the cows on milk bottles, the chickens on egg cartons, and the pigs on a packet of sausages. These representations are the stuff of children's books—pure fantasy—yet they are very often our only connections to the animals we eat. With his assemblages of processed foods and hyper-idealized taxidermied animals, DeMarte points to a world where authenticity has been pushed aside in order to make way for something far more palatable: artifice.

Bubblegum, dumbbells, and a fish. What is the common thread running through the intriguing combination of ingredients in Sheida Soleimani's still life? The

What animal did you kill today?

backdrop offers a clue: At first it looks like a textured wallpaper effect, but on closer inspection it reveals itself as a satellite image of an industrial facility. In this case, an oil refinery on Iran's Kharg Island.

In Soleimani's vibrant arrangements, we are confronted, in tragicomical terms, with an ecosystem of sorts; one that draws connections between the production of oil, the manufacture of consumer products that are mostly leisure-related, and the animals being harmed in the process. This image, *Iran Heavy*, relates to a blend of crude oil of the same name that is used in the making of bubblegum and dumbbells. The fish that once thrived now swim in the busy, highly contaminated waters that surround Kharg Island. Flopped onto the dumbbells, blowing a bubble, and with eyes bulging, the fish appears cartoonish, not something to be taken seriously, nothing more than a washed-up piece of collateral damage at the expense of our wants and whims.

Soleimani's visual strategy entices us in with humor and playfulness before transitioning into a pointed comment about consumer culture's relationship, or lack thereof, with animals. In other images that also take their name from crude oil blends, a pair of ice skates are placed among oysters; Wiffle bats and balls are intertwined with crayfish. What we perceive as harmless objects of leisure quickly lose their innocence as we are presented with the environmental cost of keeping fit or having fun. Soleimani's works are a visual feast of a very unappetizing and seemingly inescapable reality, one in which oil is the toxic life blood of an alternative food chain that runs through humans, animals, and inanimate objects.

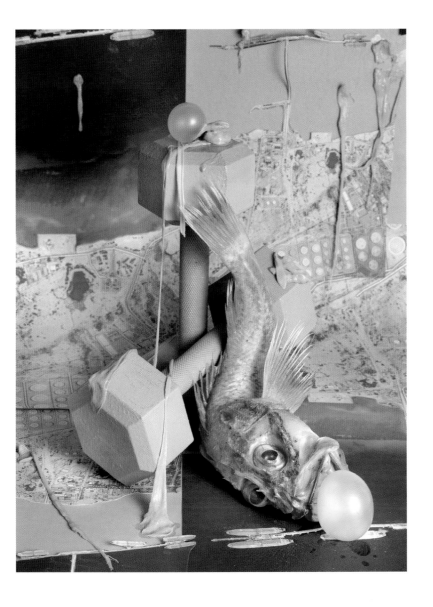

Iran Heavy, 2018

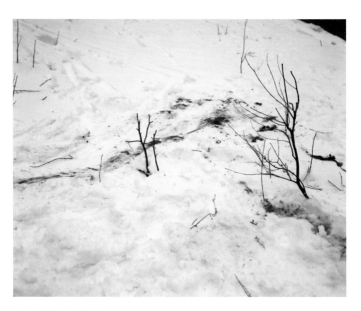

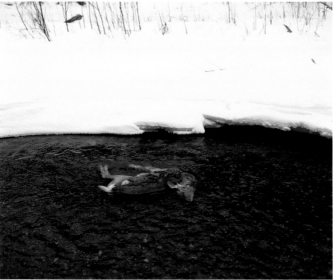

Top and bottom: Photos from the series Trails, 2009

Can
violence
be
beautiful?

In some photographs, only a few droplets of red are visible on the pure white snow. In others, the blood is so thick that it appears black in places and turns the surrounding snow into a gradient of fleshy pink. What crime has been committed here, and what body will we find if we follow the trails? Leading us on a journey into the winter landscape of Shiretoko National Park, Takashi Homma reflects on the violent act of deer hunting in northern Japan. In Japan, deer are considered by some to be sacred, but in recent years their numbers have increased to such an extent that authorities have sanctioned mass cullings. Homma's compositions show us the aftermath of the violence, often concentrating our attention on a patch of white and red ground.

Haunting as they may be, these pictures need not be seen as gruesome. The act of violence exists outside the reality of the photographs, which allows us to regard what we are seeing in abstract terms. Even though the animals have been wounded or killed by a gun, there is no condemnation of the act. Rather, a certain gestural beauty emerges from the spilled blood as we journey deeper into the woods—an expression of spiritual connectivity between animal and landscape. While the blood in Homma's images comes from many animals, killed over many years, the narrative of the series makes us feel we are following a single, wounded deer to its final resting place. Homma's photographs capture a gradual transference of life back into the earth. He finds dignity in death, even when it results from an act of violence.

How many images of tigers make a tiger?

In the ecosystem of animal images, tigers are perhaps one of the most abundant. They appear on cereal boxes and sportswear, they are mascots and merchandise, they lure tourists to exotic destinations and enchant children in books. Yet in reality, they are endangered, with only three thousand remaining in the wild. This disconnect, between millions of images of tigers and the relatively few that exist on Earth, forms the basis of Irene Fenara's tapestries titled *Three Thousand Tigers*.

For the series, Fenara used an algorithm designed to create new images of specific subjects based on millions of existing images of the same subject. Fenara, however, offered the program only three thousand images of tigers. With this limited data set, the algorithm managed to create only pixelated, abstract images that bear no relation to tigers other than an occasional color palette of mostly orange and black. Fenara then used these images to make tapestries, which were woven by artisans in India, the country where most of the remaining wild tigers live. These tapestries, which hang almost like animal skins, offer us something real, tangible, yet far removed from the animal itself. They present us with unreadable surfaces, which come to represent the kind of cognitive dissonance that exists between the uniqueness of a subject and its infinite and perpetual reproduction in images.

In Fenara's work, the tiger itself becomes a trace, an image of its image of its image. The tiger is part of the work, somewhere, but it exists in an imaginary realm, both mental and digital. Unlike in the wild, consumer culture has created an evergrowing population of tigers. It seems that their image is all that matters as we slide into a future where Tony the Tiger and his ilk might well replace the living, breathing animal on which they are based.

Three Thousand Tigers, handmade wool tapestry, 2020

When I was younger and full of energy, I worked with a boutique travel company. We specialized in photography tours and would take groups of older ladies, many of them widows, to exotic destinations around the world and teach them about the rule of thirds. On one such tour, after a winding, six-hour journey into the tea plantations of southern India, our driver, Joshi, opened the coach's luggage compartment, and as he heaved the stuffed cases out one-by-one, a cockroach flew onto the road. All the ladies screamed, as if our one-inch stowaway were wielding a jackknife. Without hesitation, I lifted my foot and stamped on the cockroach. I'll never forget the look on Joshi's face. He stared down at the oozing carcass, his mouth hanging open in disbelief.

He then looked over to me, his eyes glassy and confused, and I instantly knew the crime I had committed. Joshi was a devout Hindu. He believed that God's spirit lives inside all animals. We were two men, one from the West, one from the East, who looked at the same animal and saw totally different things. For me, the cockroach symbolized disease. For Joshi, it contained God.

Sym

bol

For millennia, animals have been used as metaphors and symbols to help us understand the universe, and ourselves.

This incident exposed what a literal, or limited, connection I had with animals. For billions of people around the world, the significance of animals, the way they value and perceive them, is rooted not in practicalities and factual knowledge but in other belief systems, ancient and mysterious, that derive from religious faith, fables, and superstition. For millennia, animals have been used as metaphors and symbols to help us understand the universe, and ourselves. The Chinese zodiac, for example, identifies a person's character traits with twelve animals; Greek myths are full of half-human, half-animal creatures, the Minotaur being one of the most famous; and when sixteenth-century astronomers looked to the stars, they saw fish, scorpions, and lions.

The significance of animals, the role they play in our lives, extends far beyond natural history and the delicate balance of ecosystems. The photographers in this section draw on the symbolic potential of animals to reflect on human relationships, personal tragedy, religious faith, and political and economic turmoil. Some find symbolic meaning in a specific animal, such as a pet, while others tap into more globally recognized belief systems that elevate certain creatures to godlike status.

ism

If no one is around to hear it,
does a cock still c r o w ?

He is a rather splendid cock, no doubt about it. But what is all
the kerfuffle about? What has, quite literally, ruffled his feathers?
Photographed by Heji Shin, this image of a cockerel is one of
several large-scale portraits that form her playfully titled series
Big Cocks. Shin captured the cockerels when they were having
a tempestuous outburst. We do not know what angered the
cocks, all we know is that they are miffed about something. This
lack of reason makes their displays of dissatisfaction appear
a little unnecessary, a little attention-seeking. Seen through
Shin's lens, removed from their environment and treated like
male models, these puffy roosters start to feel like a critique of
masculinity, especially so in an era that has seen a resurgence of
the bullish male leader, both in politics and pop culture. What,
after all, do cocks do? They make themselves heard through
sheer volume, they strut around the farmyard as if they are
invincible, if they don't like something they lash out without any
thought or foresight, and when it comes to courtship, they have
a decidedly old-fashioned, misogynistic view of females. Remind
you of anyone?

Something else surfaces in Shin's visual strategy. Whether
they like it or not, the cocks are her subjects, they are being
silenced and aestheticized by her camera. She is the one in
control here. Her photographic process is, in itself, emasculating.
The work is a retort to a conflicted culture, one that denounces
overt masculinity as pathetic, while also encouraging its
dominance through our unremitting attention. To look or not to
look? We seem unable to decide. Perhaps, just perhaps, the real
significance of Shin's Big Cocks becomes apparent only when you
divert your gaze to something, or someone, else.

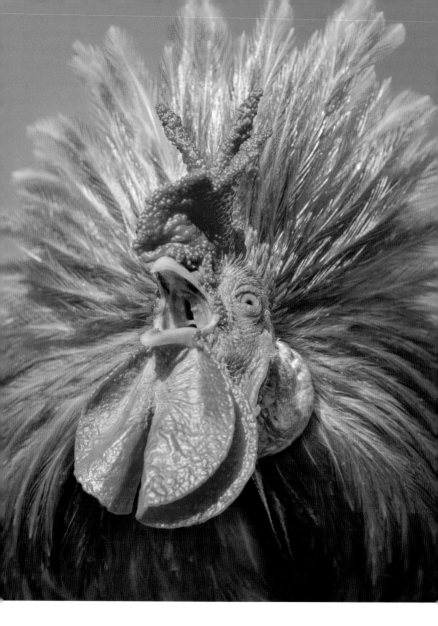

Big Cock 7, 2020

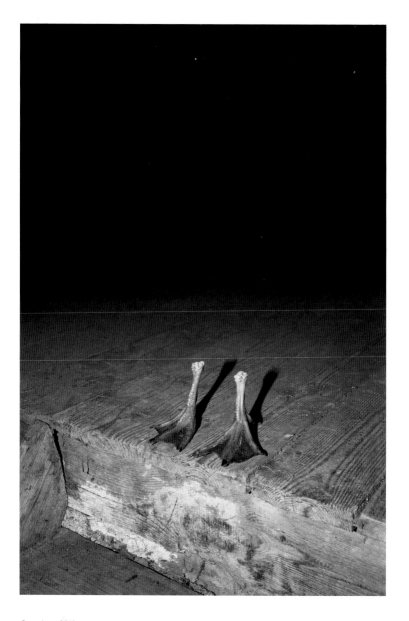

Grandma, 2018

What is your
most vivid
memory of an
animal,

Following the death of her grandmother,
Elena Helfrecht returned to her family
home in rural Germany. Using the old
house and its contents, she staged
ambiguous still lifes that reference
her childhood memories and explore
inherited traumas from her grandmother
who, as a child, lost her father in

and why is it
so vivid?

the Second World War. The animals that weave their way into
Helfrecht's images appear like inexplicable apparitions, pieces of
an incomplete puzzle. In all her images, the combination of direct
lighting with black and white creates a state of clarity and nostalgia,
of fact and fantasy. In Helfrecht's image entitled *Grandma*, a pair
of duck's legs stands disembodied on a rustic floor that fades to
blackness. Perhaps the duck carries maternal connotations, and
the absence of the body represents the absence of a grandmother
and her unshared memories. In *The Spiral*, snakes benignly encircle
a model house that looks like something from a fairy tale, but their
muscular bodies could, if they so wished, constrict and crush the
idyllic home at any moment.

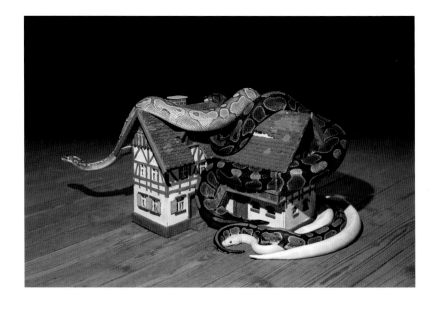

Though it's nice to find clarity in images, a clear-cut meaning, I'm not sure that's what's needed here. In using animals as a way of coming to terms with the loss of her grandmother and her direct links to the past, Helfrecht's work inevitably prompts us to reflect on our own early encounters with animals, encounters that are often deeply significant and deeply personal. Even as adults, we may find that some of our childhood experiences of animals, whether domestic or wild, are hard to make sense of. They introduce us to profound feelings such as empathy and nurturing, and they present us with fears of the unknown and anxieties about otherness. They are also very often our first direct experience of death. Just like our own personal histories, significance is there for the taking in Helfrecht's images. We just have to be willing to search for it.

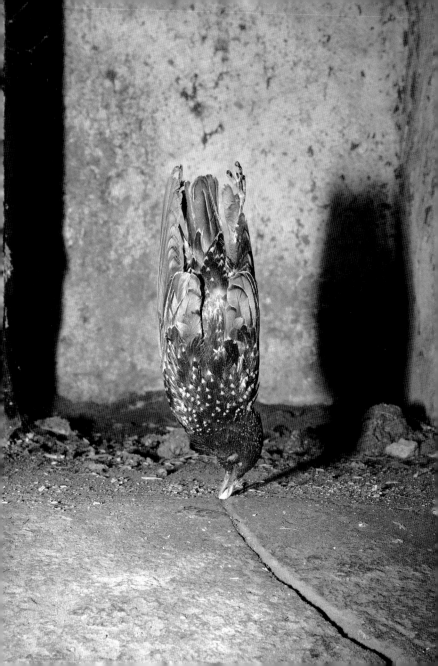

You are looking at the gate guardian to the kingdom of Shiva, the Hindu deity who created and protects the universe. That might seem absurd to some in the West, particularly those from countries like the United States, the world's most prolific consumer of beef. Daniel Naudé's series Sightings of the Sacred shows us that this disrespect for cattle is not shared the world over, particularly in non-Christian communities, where cattle continue to play a significant role in daily worship. The animal in this portrait, a Kangayam cow, is central to a southern Indian harvest festival called Mattu Pongal. Photographed from below, with long, elegant horns painted in yellow and red, the bovine stands proud, with magisterial status. Rarely do we see cattle on their own; usually they stand anonymously in herds, their expressions a little dumb and distant. Yet here, our gaze is met. We are, in fact, being looked down upon. Naudé's obsequious viewpoint reveals that the significance of cattle goes far beyond their milk and their meat, and asks us to consider them as something more than products to be genetically altered, factory-farmed, and processed.

Do some animals know that they are "special"?

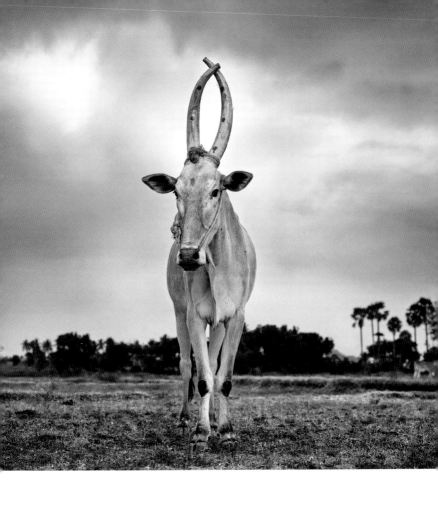

Mattu Pongal 28, Kanakkandal District, Tamil Nadu, India, 2014

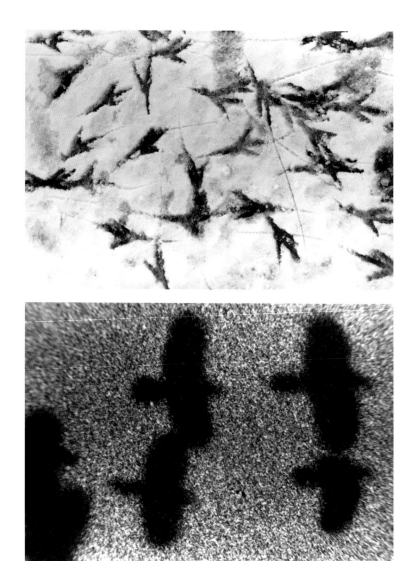

Top: *Wakkanai*, from the series Ravens, 1975
Bottom: *Noboribetsu Hot Spring*, from the series Ravens, 1977

What animal represents your state of mind?

The raven was Masahisa Fukase's bird of choice for expressing his mood following a divorce. His fascination with ravens—which grew into an existential belief that he was a raven—started with a solemn train journey across Japan, from Tokyo in the south to his hometown of Hokkaido in the north. Fukase photographed the birds from his moving carriage and occasionally stepped outside with his camera at station stops. Like menacing watchmen, the ravens stand alone or in flocks against bleak, postwar landscapes buffeted by the elements.

Pictured in grainy black and white, the birds become a foreboding, lingering motif of isolation and loss. Occasional photographs of menacing cats appear in this series, as do images of an enigmatic woman (Fukase's ex-wife), making this a deeply psychological photo essay. In one extremely cropped, grainy image, ominous raven silhouettes fly at altitude, like the all-too-familiar harbingers of destruction from a recent world war. In another, the birds are absent, their footprints in the snow serving as literal traces or memories of past events. Memories so often trap us in our past, yet here the footprints resemble the freedom of flight. With these ravens, Fukase saw something that reached beyond the ubiquity of collective symbolism associated with birds and found an allegory for lost love in a decaying postwar Japan.

Is
taxidermy
a form of
torture?

It started with a crocodile, not more than a foot long, that sat motionless on his father's desk. With its staring glass eyes and dry reptilian skin, the crocodile became an object of boyhood fascination for Christian Houge. It was dead but not laid to rest. This primordial hunter had become the trophy, reduced to a spectacle for human amusement, denied the honor of returning to dust. Houge is now a wildlife rescuer of sorts. He collects taxidermied animals from around the world, brings them to his studio in Oslo, and then burns them.

Even after we realize that the eyes staring back at us are glass, it's hard not to feel unsettled when viewing Houge's burning animals. Houge documents the animals at various stages of combustion against colonial-style wallpaper, the kind found in hunting lodges and fusty natural-history institutions. As the animals succumb to the fire, we see their bodies change. The fur or feathers go first, then the skin or scales, but, of course, those eyes stay staring until the very end. The flames intensify the animals' gazes. It is as if the burning brings them back to life, unlocking whatever soul might still remain inside them.

Houge's act, which might appear almost sadistic, is, in fact, one of kindness and empathy, a form of cremation that releases the animals from their current state. A state that traps them between life and death. The burning animals encapsulate our relationship with the natural world. Our ancestors' ability to make fire marked a point of separation between us and animals, yet Houge uses fire as a means of reconnection. These taxidermied animals are the victims of our desire to turn nature into a spectacle, and yet here they are being freed by the flames. Just like us—just like everything—they are granted the right to no longer exist.

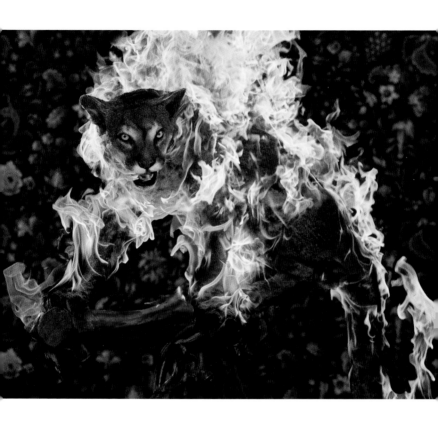

Above: *Puma*, 2019
Following spread: *Polar Bear*, 2019 and *Polar Bear Burnt*, 2019

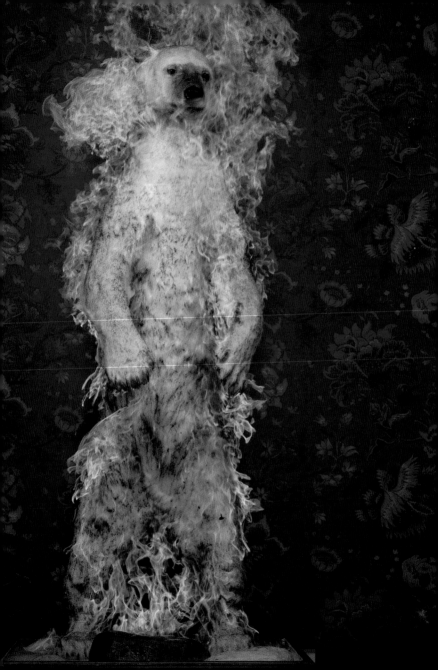

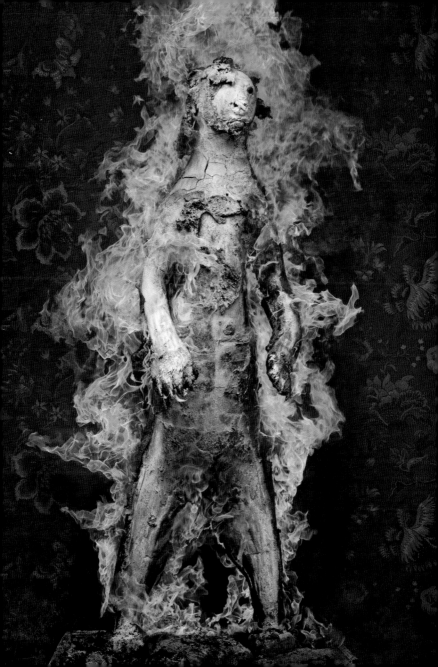

Above and following spread:
Photos from the series The Splitting of the Chrysalis & the Slow Unfolding of the Wings, 2018

What do caterpillars dream of inside their cocoons?

A country in economic turmoil. A population at loggerheads with their government. A humanitarian crisis unfolding. Such was the state of play in Greece following a decade-long financial collapse that started in 2009, and in this situation Yorgos Yatromanolakis returned home to Crete. Seeking sanctuary from the storm on this remote island of agriculture and wilderness, Yatromanolakis sunk into a state of deep, isolating introspection that he likens to a metamorphosis, almost as if he had been cocooned inside a dark, transformational chrysalis that protected him from the outside world.

This mindset is mesmerizingly captured in his resulting series, The Splitting of the Chrysalis & the Slow Unfolding of the Wings. Taking his photographs during the ambiguous hours between night and day, Yatromanolakis presents a murky dreamscape of illuminated rock formations, spindly flora, forlorn livestock, and agile pond life. Light glistens on ripples of water, fire feeds off patches of dry grass, sheep appear in stasis, like ghostly apparitions emerging from the darkness, and amphibian life-forms exist in a state of transformation. As one ventures further into Yatromanolakis's nocturnal ecosystem of hope and fears, of familiar pasts and uncertain futures, one senses that transformative change is possible in other spheres. Here, the power of metamorphosis in nature spawns a vision of social, political, and personal rebirth in the imagination.

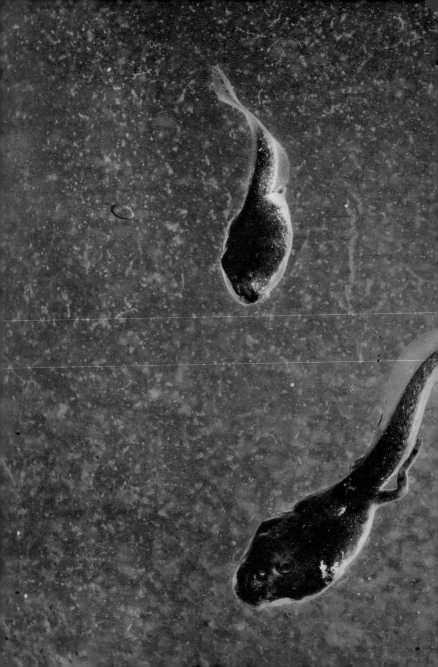

Why
is
Heaven
in
the sky?

Following the death of her six-year-old daughter, Graciela Iturbide
began photographing Mexican rituals surrounding death in order
to come to terms with her loss. While documenting the funeral of
an *angelito*—a dead child whose soul is believed to rise into the
sky—Iturbide came across the body of a man in the street whose
flesh had been pecked away by birds, now circling overhead. So
violent was the scene that Iturbide interpreted this encounter as
death itself, telling her to look away, to turn her attention from
the corpse to the birds. As is the case in this image, dense flocks
fill the sky in many of her compositions. Here, the telephone pole
makes a clear reference to a crucifix, leaning ever so slightly as if
succumbing to the birds. While foreboding, the symbolic presence
of birds in Iturbide's photographs extends beyond the morbid.
There is something unfathomable, even spiritual about the
precision of their movements; when frozen by the camera, it's as if
each of their delicate and distinctive silhouettes has been placed
there by hand—perhaps the hand of God, who created a creature
able to fly in the heavens and walk on the Earth. It is easy to
imagine that Iturbide, in looking up at the birds, was, in fact, seeing
the souls of the dead. For her, they were one of the few tangible
links to a lost daughter.

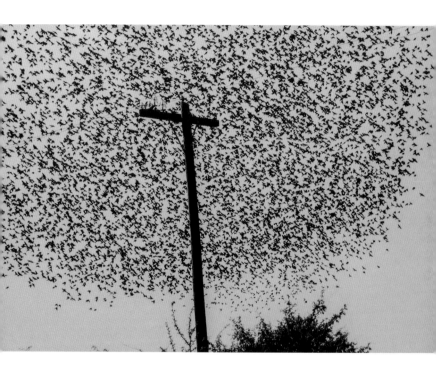

Pájaros en un poste, Guanajuato, 1990

**MADHAVAN
PALANISAMY**

Madhavan Palanisamy is a believer in Carl Jung's theory of "the shadow" (the suppressed part of our mind that supposedly harbors our pre-human links to animals), and his ambiguous assemblages of his aging father act like windows into the subconscious, a place where humans *are* animals. While caring for his father, who was blind and recovering from a stroke, Palanisamy would take nightly walks through his hometown in order to gather his thoughts. On these walks, he encountered stray dogs and abandoned work animals such as cattle, mules, and horses

Are animals aware of aging?

that would occasionally follow him, as if his presence gave them a sudden sense of purpose. In these lost, unwanted creatures, Palanisamy saw parallels with his father's physical and mental decline: Like these once-valued animals that now exist without purpose other than to graze on garbage, a respected teacher and Marxist scholar now confronted with his own mortality and the legacy of his life's work, which he can no longer pursue, instead spends much of his life in front of daytime TV.

Using expired black-and-white film and direct flash, Palanisamy made stark, dislocating collages, occasionally annotated with simple line drawings and text recalling childhood memories. Like glimpses of disquieting dreams, nothing in Palanisamy's images is easy to decipher. Animals on scrubby ground stare back at us with reflective eyes, while the body of Palanisamy's father appears doddery and absent. In these layered images, a primal state of being surfaces, one that blurs the lines between man and beast, and one that reveals itself only when the end draws near.

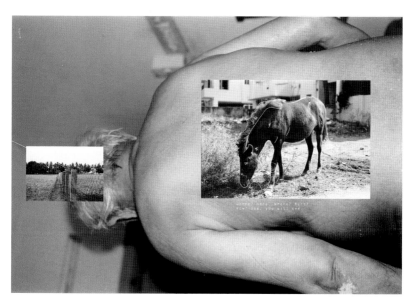

Top and bottom: Photos from the series Appa and Other Animals, 2019

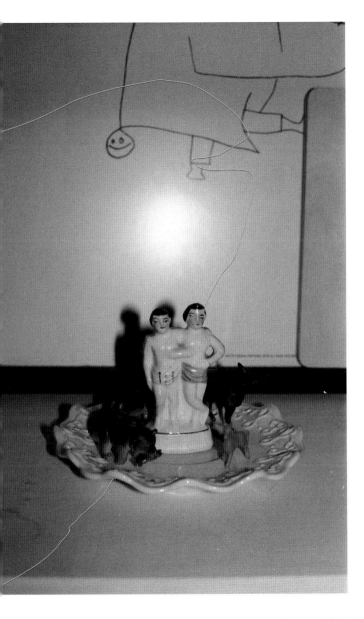

Diptych from the series Appa and Other Animals, 2019

Inter

Part One: Finsbury Park, 2009

I needed tennis balls, so I walked from my flat in north London to Sports World on the other side of Finsbury Park. About halfway into my journey across the park, a squirrel went stock-still in the damp grass about thirty feet in front of me. There was something about the intensity of its gaze that caused me to stop. The squirrel proceeded to hop toward me, occasionally pausing, as if questioning its own actions. Closer and closer it came, until it was sitting at my feet, its little eyes staring up at me like two glossy black holes. When the squirrel jumped onto my shin, my initial thought was how weightless it felt, gripping onto my jeans. It then scaled my leg, its movements jerky, until it reached my hip. I think that was the point when we both started to question what we were doing, because there it stayed—assessing—for perhaps five seconds, before dashing into the distance without offering me any explanation.

Part Two: St. James's Park, 2011

I was taking a Sunday stroll in St. James's Park with my girlfriend. The park was busy with tourists because it lies between The Ritz and Buckingham Palace, so to escape the crowds we left the path and cut across the grass. In the distance a group of squirrels were nibbling on fallen seeds. I thought nothing of it—why would I?—until one of them paused, looked up, and swiveled its body toward me. I'd seen that look before. "Darling," I said. "Hold still. That squirrel over there is about to run up my leg." Closer and closer it hopped, in that familiar stop-start fashion, until it was sitting at my feet. This animal felt a little heavier than the last, and was perhaps less susceptible to whatever energy I was emitting, because it reached only my knee before a twitch of realization caused it to scurry back to its friends.

action

I reasoned that both instances were cases of mistaken identity—that the squirrels must have thought I was a newly planted tree. But I can't be sure. Perhaps they knew exactly what they were doing. Perhaps there is something special about me—within me—that called to them. Or do I simply wish it were so? The squirrels have left me in a state of wanting, left me to project my own meaning on our encounter that may, or may not, mean anything at all.

Here, the photographers draw on the inherent ambiguity of their medium to explore our interactions with animals, interactions that never satisfy our innate desire for meaning. In reflecting on the language barrier between the animal kingdom and us, their work exposes a relationship fizzing with fear and longing, logic and imagination, anticipation and bewilderment—very likely on both sides. Their work suggests that the balance of power is not as tilted in our favor as we like to think. With a look, gesture, or leap onto the leg, even the smallest creatures are able to confront us with the limits of our knowledge, to give us a glimpse into a level of consciousness far beyond our understanding.

The balance of power is not as tilted in our favor as we like to think.

Do you
think
you've ever
appeared
in an
animal's
dream?

Perhaps you are being looked at right now. Perhaps there is a spider hiding in the corner, a bird sitting in a nearby tree, or a cat silently staring out from a neighbor's window. And so what if this is the case? We find the gaze of animals intriguing more than intrusive. Their attention generally does not pose a threat, or put us on guard, like the gaze of a stranger. Is this because we assume the animal is not thinking anything when it looks at us, that there is no meaning or motive behind its gaze? But what if the animal is, in fact, thinking something? What if it is judging us in some way?

Above and following spread: Photos from the series Animals That Saw Me, 2008-14

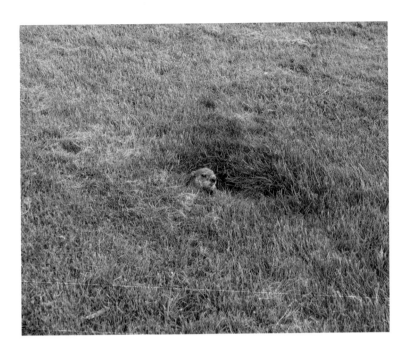

For years, Ed Panar has been photographing his visual exchanges with animals, the results of which are contained in his books *Animals That Saw Me: Volume One* and *Animals That Saw Me: Volume Two*. Crickets, cows, snakes, cats, dogs, stick insects, raccoons, and frogs stare into the camera. Adopting a snapshot approach, his seemingly uncomplicated aesthetic is a response to his unexpected interactions with animals. His photographs crystallize a standoff between two parties, one entirely based on anticipation and assumption, like the elastic moment in a duel before two gunslingers draw. Each image treads a line between significance and insignificance, a record of an interaction that is impossible to fully understand, yet one in which two worlds intersect momentarily. Panar becomes pulled into the animal's kingdom and the animal into his domain.

What at first appear like casual snaps end up embodying the language divide between humans and animals, a relationship in which neither party can ever predict the outcome with certainty. Humans value vision above all other senses; seeing and being seen validates our existence. Perhaps the same is true for animals? Perhaps they, too, are feeding off our gaze. Panar's collection of lingering looks makes you wonder what animals are seeing when they look at us so intently. Is every human sighting somewhat confusing, a little inexplicable? Do we cease to exist as soon as we are no longer in their line of sight, or does part of us remain forever in their consciousness?

Trip and Alan, with their Jack Russell, Key West, Florida, 1988

What are the pros and cons of being someone's pet?

The animals in Sage Sohier's photographs sit at dining tables, sleep in beds, and slither on sofas. The close bond between people and pets is ever present; eccentricity abounds. In fact, any one of the animals in Sohier's photographs could be substituted for a child, and I doubt the owner's body language would seem any less apropos. People love their pets. No news there. But these intimate photographs probe a little deeper than that. In some, a slight tension occasionally shows its teeth. Here, Trip and Alan stand, or loom, over their Jack Russell as it lies on its back, paws aloft, cute as can be. While the couple's love for their pooch is without question, there is something a little conditional about their affection; and, as happy as the dog seems, there is something a little manipulative about its behavior. It's almost as if this exchange of looks is pregnant with longing, but longing for what?

In another image, Deborah kneels in her living room, cradling the head of her llama as if it were a sacred animal. Perhaps it is, to her. Yet the llama's eyes look dumb; who knows what it is thinking and feeling, surrounded by all the soft furnishings. Each of Sohier's photographs pulls us in two different directions. While the animals are clearly loved, they often seem a little out of context. It's as if their position as pet denies them a certain aspect of their "animalness." The condition of cohabitation, it appears, is that the animal needs to adapt to its owner's demands, which, in essence, is to behave more like a person than an animal. It's as if our love of pets is based not on what they are but on what we want them to be: human.

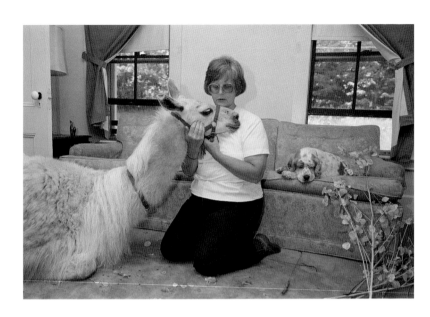

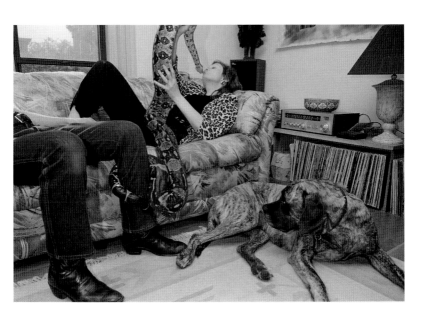

Opposite: *Deborah in Living Room with Snowy the Llama and Winnie, Freedom, NH*, 1993
Above: *Larry and C.J. with Miles and Nikita, Brookline, MA*, 1992

The military drone, or more accurately, its remote operator, would have assessed these two donkeys as "meaningless" in relation to the seek-and-destroy mission at hand—just glowing white pixels that

How do images affect your relationship with animals?

represented life, but not life worth preserving. They were, however, not so meaningless to Clément Lambelet, who screenshot their existence while watching drone footage of a U.S. attack on an ISIS camp on YouTube.

Struck by this passing moment of normality between explosions, Lambelet started sifting through other drone footage in search of further glimpses of everyday life taking place in the midst of warfare. Lambelet's screenshots of desert landscapes, lone figures, clumps of trees, parked cars, and standing animals deny us the silent flash of an explosion and the ensuing clouds of smoke. Instead, we are forced to linger on very relatable subjects pictured through the abstracting lens of an agent of destruction. Here, both donkeys are looking in the same direction, their attention, their consciousness, clearly caught by something. This display of sentience that had no significance in the flow of the original footage becomes heightened, strangely profound.

Untitled, from the series Two Donkeys in a War Zone, 2017

The animals are immediately recognizable, but there is something disquieting in the way they have been reduced to their simplest forms, rendered uncomplicated, like a child's drawing. Preserved and removed from their original context, the donkeys come to represent the dehumanizing nature of modern warfare and the psychological distancing that comes with remote viewing. With Two Donkeys in a War Zone, Lambelet finds a way to subvert the visual language of war in order to reestablish the lost link between the represented and the real. He reinserts a touch of humanity into the fuzzy footage of foreign lands that we have become so accustomed to viewing. He finds a semblance of conscience, a moment of pause, in a digital landscape of death and destruction.

Above and opposite: Untitled, from the series Two Donkeys in a War Zone, 2017

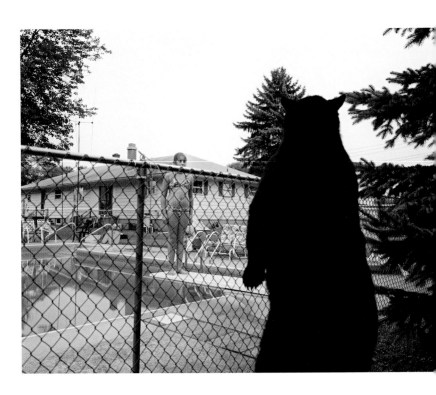

Watering Hole, 2005

Do animals see us as animals?

The size and posture of the girl and bear are strangely similar. Standing on either side of the chain-link fence, both are surrounded by their creature comforts; one has her swimming pool, the other the woods. However, the girl, and the photographer for that matter, are perfectly safe, because the bear in Amy Stein's image is, in fact, stuffed. With her Domesticated series, Stein explores the ever-present tensions between humans and nature on the fringes of urban environments. Using real and taxidermied animals, Stein re-creates stories reported in the local news or shared by word of mouth about human encounters with the wild. Her staged scenes take place in semirural locations, where both human and animal appear a little out of place and the viewer is left unsure about which is encroaching on the other.

Sometimes it is the animals that appear like predators: A pair of lynx sit on the timbers of a half-built house, claiming it as their own. Other times humans have the upper hand: A man leans over his fence, pointing a shotgun at a wild turkey. And then there are occasions when no threat is apparent, just an awareness of "the other": A woman stands watering her birdbath, clearly an indication of her willingness to welcome nature in; but as she stares up at the sky, no birds are visible. Fences around gardens and the walls of houses start to feel permeable to whatever might wander in from the wild. Rather than effective defenses, these physical structures come to resemble psychological barriers, boundaries of the imagination, defense mechanisms, as it were, that prevent or protect humans from feeling part of the natural world. In Domesticated, Stein highlights our compulsion to connect with nature, but only on our own terms. The tension between coexistence and control that occurs in semirural, or semiurban, environments creates an ever-present psychology of fear for those living on either side of the fence.

Do animals
know something
we don't?

Snail Drawings, Daniel Ranalli's long-running series, sees him walking along beaches and collecting snails in the damp sand of the intertidal zone. When his pocket is full, Ranalli will return the snails to the sand, often in a simple line, a rectangle, or, as is the case here, a spiral. Before long, the snails break formation, their tracks in the sand allowing us to trace their individual and seemingly random pathways. Whatever order the artist had imposed on these animals has been entirely obliterated. Photography plays its part in this dissolution. The medium's ability to compress time and change into the uncomplicated form of "before and after" presents us with consequences rather than process. The only thing that matters is the start and the end.

Yet something is happening here, something adding up to more than the sum of its parts. Perhaps we can learn from the actions of these lowly, un-cerebral creatures that our need to impose order on the natural world, to shape it into patterns and behaviors recognizable to us but irrelevant to animals, will always descend into a delightful, and occasionally dangerous, chaos. And why would we expect otherwise? Most animals have been here far longer than us. A snail's five hundred million years on earth makes our two hundred thousand seem a little insignificant, or inexperienced, to say the least. With Ranalli's snail drawings, the marks in the sand soon vanish with the rising tide. Most likely, the snails have no memory of being suspended between his thumb and index finger and are happy to simply go with the flow. Perhaps we should learn something from that.

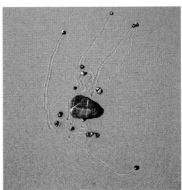
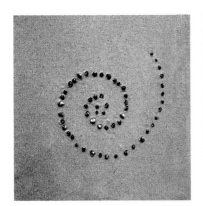
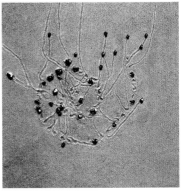

Top: *Rock Vein #3*, 2013 | Bottom: *Spiral #9*, 1995

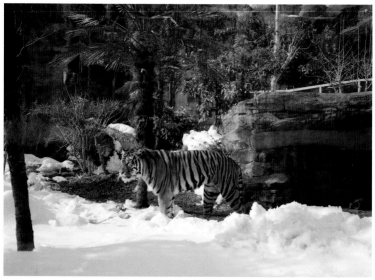

Above and following spread: Photos from the series Tiger 2, 2013–15

The tiger sits on a ridge surveying his kingdom—all two thousand square feet of it. The tiger looks forward. He looks to the left. The tiger gets up. He lies back down. Snow appears on the ground. The tiger walks through the snow. The tiger lies back down on his ridge. The snow has melted now. A change of season, but not of scenery. What are we supposed to be looking at in Masuda Yoshinori's series of photographs of a tiger in a zoo? Over a number of months, Yoshinori photographed the tiger through the glass. His images have a snapshot quality; the compositions

Is a photograph a form of captivity?

do not appear too considered, and he has made no attempt to adjust the white balance in order to maintain the continuity of color from one picture to the next. In many ways, the mundanity of his technique reflects the repetitive, day-to-day existence of his subject.

The coming and going of snow, the changes in light, clearly show that these pictures were taken over a period of time, yet time itself does not seem to exist in these images. The tiger's life does not advance from one picture to the next. The narrative promise that we come to expect from a sequence of images does not materialize. And that's just it. Our encounters with zoo animals tend to last seconds or minutes and take place on memorable days. When we leave the zoo, our lives move on; our experience becomes memory, but the animals stay as they were. Effectively, the animals are just spectacles that cease to exist when we stop looking at and taking pictures of them. By returning to the tiger again and again, by photographing its unchanging existence, Yoshinori reduces the tiger to an image while capturing the monotony of its existence. He makes no attempt to provide us with a highlight, each image is equal, each image replaces the last without offering a distinct sense of progression. We are unwittingly asked to participate in the tiger's state of temporal captivity.

We begin with a crab in Emilio Vavarella's film *Animal Cinema*. It appears to be burrowing into patchy dry ground before turning its attention to us. When we are pulled into the hole, we find ourselves underwater, entwined in the tentacles of an octopus. Its suckers gently explore the camera as we travel across the seabed. Tentacles become the paddling legs of a dog. As we reach shore, dangling from its mouth, we enter a whirling frenzy before being laid to rest. A nose sniffs its way into the frame. It belongs to a grizzly bear. The bear offers us an uncomfortably close encounter with the inside of its mouth, its jaws dripping with hunger, as if it can smell us, the audience, through the lens. From there we hitch a ride across a grassy plain—courtesy of a lion—and are subsequently accelerated up a tree, our journey taking us higher and higher into the ever-narrowing branches, thanks to the dexterity of a gray squirrel. And so continues Vavarella's film, in which he used YouTube footage of

Does visual language limit our view of the natural world?

animals taking control of cameras planted in the wild to place our gaze at the mercy of the natural world.

The footage has a childlike playfulness, the product of someone, or something, that has not learned, or been limited by, the dos and don'ts of visual language. Compositions of strange, unfamiliar beauty and long, uninterrupted shots adhere to a different kind of narrative, one that could take us anywhere for unexplained reasons. In the hands of a human, a camera is political, a subjective means to show what is and what is not important; but in the mouths, tentacles, or claws of creatures, politics is dispensed with and the camera becomes a tool for an entirely different purpose—whether that's food, material to make a nest, or an object of play. Even a remote camera that records animals unaware has been consciously placed in position, its frame composed so that the animals fit within an accepted aesthetic framework. With *Animal Cinema*, Vavarella takes us on a magical journey. Though the film seems haphazard and messy at first, when the humor subsides, we come to realize that the animals have a purely reactive, instinctual view of the world that humans could only hope to achieve.

From top:
Woman on Bench, 2018; *Man with Cigarette*, 2018; *Tree and Fence*, 2018; *Magic Tree I*, 2018

For an animal
to be real,
does it
need
to e x i s t ?

Sink yourself into a nocturnal narrative in Bastian Thiery's photobook *Humpelfuchs* (limping fox). One evening, on a walk around his Berlin neighborhood, Thiery spotted a lame fox. The fox allowed Thiery to approach it but would back away when he got too close. This dance was repeated a few times before the fox finally disappeared into the night, leaving Thiery with a yearning to encounter it again. And so begins a nocturnal photographic exploration in search of this elusive animal. But what Thiery ends up drawing out from the darkness are disquieting forms, lonely figures, and startled creatures both domestic and wild. Thiery's stark, direct flash illuminates foreground details against ominous blackness, creating a Lynchian dream world of disjointed observations and semisensical narratives: Trees like amorphous blobs engulf metal fences; garish flowers of purple, pink, and green may have hallucinogenic properties if smelled or eaten; a woman sits alone on a park bench, brushing her blonde hair as if gazing into a mirror, but her mirror is darkness.

The subjects of these observations could be no more tangible than figments of the imagination, details that would not exist had Thiery not drawn them out from the night. Was his *Humpelfuchs* simply an apparition that coaxed him, for whatever reason, into the darkness? Foxes do make an appearance in his images, but is it *the* fox? Does it matter? The animal takes on the role of gatekeeper to another reality in which perception is full of unexpected possibilities. The ambiguous interaction between human and animal opens up an alternative view of familiar streets where everyday encounters no longer make perfect sense. One starts to wonder what Thiery was really searching for. Come to think of it, what is my *Humpelfuchs*? What is yours?

Fox II, 2018

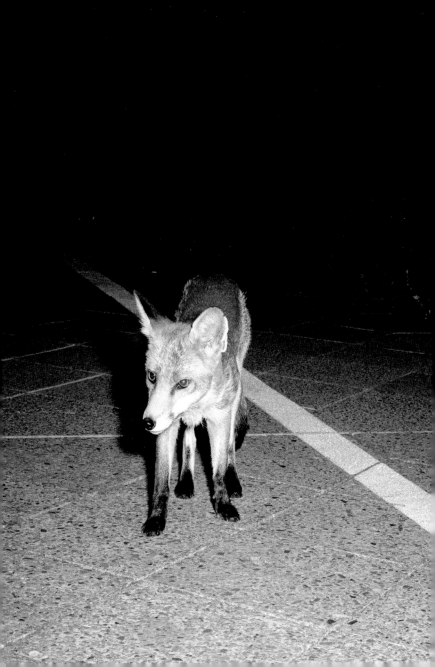

PHOTO CREDITS

ACKNOWLEDGMENTS

I would like to extend a gargantuan thank-you to the following people whose experience, creativity, and insight helped to shape this book. To my editor, Michael Sand, and the design and editorial team at Abrams: Diane Shaw, Deb Wood, Elizabeth Broussard, and Glenn Ramirez. Thank you to my kind and supremely talented personal editor, Riley Johnson, for his ongoing and thoughtful comments, and to my agent and voice of reason, Katherine Cowles. Image research was undertaken by the unstoppable Kim Hungerford and Jack Harries of RAFT, and further thanks go to Yana Wernicke, James Bryant, Selwyn Leamy, Caitlin Walsh, Dan Golden, Lukasz Pruchnik, and Danielle Mourning. And, of course, thank you to all the photographers who generously contributed work and so graciously tolerated my working methods that were, at times, a touch chaotic.

Editor: Michael Sand
Managing Editor: Glenn Ramirez
Designer: Diane Shaw
Design Manager: Shawn Dahl, dahlimama inc
Production Manager: Kathleen Gaffney

Library of Congress Control Number: 2021932417

ISBN: 978-1-4197-5146-2
eISBN: 978-1-64700-570-2

Printed and bound in the United States
10 9 8 7 6 5 4 3 2 1

Abrams Image books are available at special discounts when purchased in
quantity for premiums and promotions as well as fundraising or educational
use. Special editions can also be created to specification. For details, contact
specialsales@abramsbooks.com or the address below.

Abrams Image® is a registered trademark of Harry N. Abrams, Inc.

ABRAMS The Art of Books
195 Broadway, New York, NY 10007
abramsbooks.com